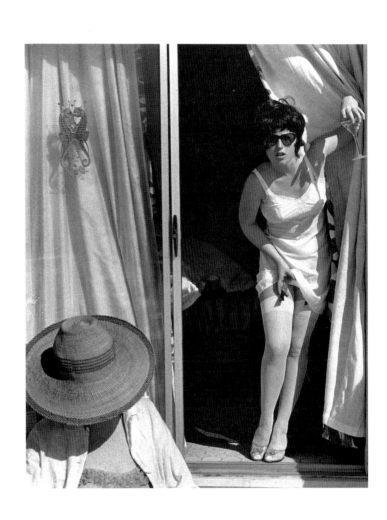

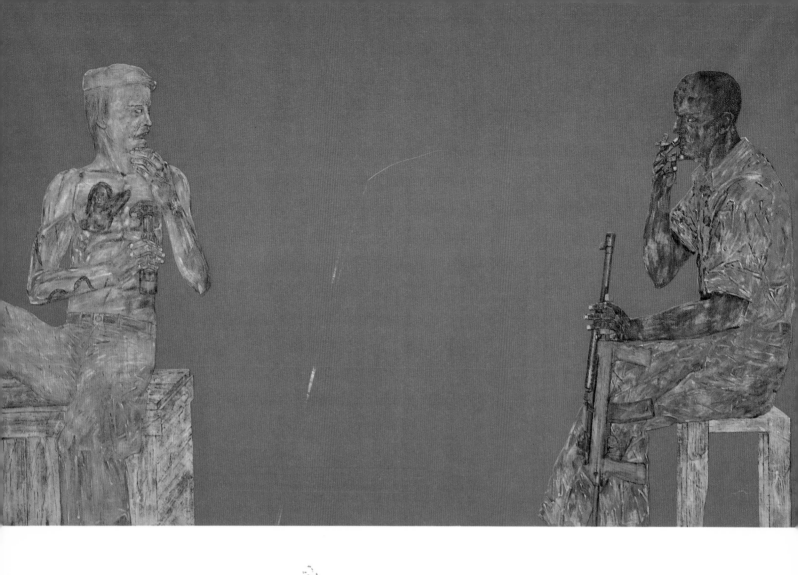

JUNE 1–AUGUST 25, 1991

SAN JOSE MUSEUM OF ART

COMPASSION

AND PROTEST

RECENT

SOCIAL AND

POLITICAL ART

FROM THE

ELI BROAD

FAMILY

FOUNDATION

COLLECTION

CROSS RIVER PRESS

A DIVISION OF ABBEVILLE PRESS, INC.

NEW YORK

Copyright © 1991 San Jose Museum of Art

110 South Market Street, San Jose, California 95113

All rights reserved under international copyright conventions. No part of this book may be reproduced or utilized in any form or by any means, electronic or mechanical, including photocopying, recording, or by any information storage and retrieval system, without permission in writing from the publisher. Inquiries should be addressed to Abbeville Press, Inc., 488 Madison Avenue, New York, NY 10022.

Sponsored in part by Kaufman and Broad Home Corporation. Additional ongoing support is provided by the City of San Jose and the City of San Jose, Fine Arts Commission. The San Jose Mercury News provides continuing sponsorship of San Jose Museum of Art publications.

Special thanks to Gannett Outdoor of Northern California for its support of an artists billboard project in conjunction with the presentation of this exhibition in San Jose.

Cover: Robert Longo, Untitled (White Riot Series), 1982

Half-title: Cindy Sherman, Untitled Film Still, 1978

Frontispiece: Leon Golub, Mercenaries III, 1980

All dimensions are given in inches; height precedes width precedes depth.

Edited and designed by Marquand Books Inc., Seattle

Editors: Patricia Draher and John P. Pierce

Designer: Scott Hudson

Composition by The Type Gallery, Inc., Seattle

Printed and bound in Japan by Toppan Printing Co., Ltd.

Library of Congress Catalog Card Number 90-63806

ISBN 1-55859-301-2 (cloth)

ISBN 0-938175-12-2 (paper)

Welcome to R.A.F. Greenham Common copyright © 1985 by Sue Coe

F-111 copyright © 1991 by James Rosenquist/VAGA, New York

Photo credits: Josh Baer Gallery, p. 10; Paula Cooper Gallery, p. 27; Robbie Conal, p. 84; M. Lee Fatherree, p. 13; Galerie St. Etienne, p. 30; Gannett Outdoor of Northern California, p. 14; Anne Kohs and Associates, p. 13; David McKee Gallery, p. 8; Robert Mates, p. 8; Metro Pictures, cover, pp. 1, 54, 63–66; Milwaukee Art Museum, p. 9; Museum of Contemporary Art, Los Angeles, p. 85; Douglas M. Parker, pp. 23, 47; David Reynolds, pp. 10, 34; Tony Shafrazi Gallery, pp. 40–41; Sonnabend Gallery, pp. 11, 57; Ivan Dalla Tana, pp. 41, 60; Washington University Gallery of Art, p. 79.

TABLE OF CONTENTS

ACKNOWLEDGMENTS

EXHIBITION ACKNOWLEDGMENTS

Compassion and Protest: Recent Social and Political Art from the Eli Broad Family Foundation Collection reflects the extraordinary interest today in social and political art. The museum expresses its gratitude, first and foremost, to the artists whose works demonstrate this concern. We are also most grateful to Eli and Edythe Broad for their generosity in lending a substantial portion of their holdings for the occasion of this exhibition.

The organization of *Compassion and Protest* and the oversight of the catalogue were ably carried out by curator Colleen Vojvodich. Many administrative details were handled by Dianne Hoover, the museum's curatorial assistant. Michele De Angelus, curator of the Eli Broad Family Foundation, possesses a wealth of knowledge about the holdings, which she shared with patience and goodwill.

The museum expresses its thanks to each and every one of the authors of this publication and to Marquand Books, Inc., for editing and design. I also acknowledge the helpful suggestions of Paul Taylor, critic and curator, and Jacquelynn Baas, director of the University Art Museum at the University of California, Berkeley.

I want to thank all of the staff members who worked on this project, and the entire staff joins me in thanking the board of trustees for its support.

I. MICHAEL DANOFF
Director

NEW MUSEUM ADDITION ACKNOWLEDGMENTS

On behalf of the board of trustees, it is my pleasure to thank the many individuals whose labor of love has made possible the inauguration of a major new addition to the San Jose Museum of Art. For their support of the building program, the museum is grateful to the city of San Jose and its Redevelopment Agency, particularly agency director Frank Taylor; former mayors Janet Gray Hayes and Tom McEnery; and the Honorable Susan Hammer, mayor of San Jose.

I am grateful to the Museum Foundation Board, chaired by Drew Gibson, for its unstinting efforts. Mr. Gibson and I thank all those donors whose generosity has taken us to this point. We are especially grateful to Venture Fund donors. The architectural firms of Skidmore, Owings, Merrill and Robinson, Mills, and Williams are to be congratulated for their outstanding design work. Averill Mix, also of the Museum Foundation Board, has been in many ways the actual project manager for the museum. I am also grateful to the businesses and their employees who worked on the construction of the new addition.

I want to acknowledge former museum directors John Olbrantz and Albert Dixon for their work on this project. And, congratulations to director I. Michael Danoff and his staff for their successful efforts on the opening of this facility and the presentation of an outstanding exhibition.

JAMES R. COMPTON
President
Board of Trustees

MAYOR'S ACKNOWLEDGMENTS

On behalf of the city of San Jose, I am pleased to have the opportunity to congratulate all those associated with the opening of the San Jose Museum of Art's handsome new addition. Having the building inaugurated by this important exhibition and publication is indeed a meaningful step in the history of the museum.

As San Jose continues to grow, the museum will become an even more vital asset to the city's residents and visitors. The new addition symbolizes exceptional cooperation between private and governmental sectors—the board of trustees, the Foundation Board, staff, the Redevelopment Agency, and the city of San Jose.

Again, congratulations.

SUSAN HAMMER
Mayor
City of San Jose

FOREWORD

Eli and Edythe Broad are remarkable collectors whose contributions to the art world have been numerous. They have been steadfast in their commitment to collecting and to fostering the study and appreciation of contemporary art, and have been unfailingly generous in volunteering their time and providing financial support to museums in the United States.

The Broads began collecting in the 1960s. Since that time, their devotion and connoisseurship have enabled them to assemble two of the most important collections of contemporary art in the world. Their private collection, the Eli and Edythe L. Broad Collection, contains important works from nearly every post–World War II movement, including major pieces by artists such as Roy Lichtenstein, Frank Stella, Joan Miró, and Henry Moore. Their awareness of and sensitivity to the many challenges that museums face today, coupled with their concern that many great works of art are becoming inaccess-

ible as they disappear into private collections, compelled Eli and Edythe Broad to create a unique resource: the Eli Broad Family Foundation. The foundation was established in 1984, and in 1988 a research and loan facility was opened in Santa Monica, California. The renovated five-story building contains space for exhibitions, collection storage, photo and documentary archives, a library, and offices for the foundation's curatorial staff.

The foundation collects major works by both established and emerging artists. Of the more than one hundred artists included in the collection, nearly half are represented in depth. For instance, the holdings of Cindy Sherman's work essentially serve as an archive; a print of virtually every photograph she has created since 1978 is included. The collection also contains significant works by pivotal artists such as David Salle, Barbara Kruger, and Jenny Holzer.

A wealth of outstanding exam-

ples of politically charged art is held in the Eli Broad Family Foundation collection. In part this comes from the Broads' interest in and willingness to take chances with difficult or challenging art, ranging from Leon Golub's and Sue Coe's explicit portrayals of injustice and abuses of power to Cindy Sherman's photographs suggesting social imbalances resulting from traditional gender roles.

The foundation's diverse collection provides many opportunities for major museum catalogues and exhibitions. That this publication interprets and documents a selection from the collection is only part of its objective. Its intention is also to explore the wider social and political focus and implications so deeply evident in the works of many contemporary artists. The following essays examine the roots, forms, and nature of recent artistic expression dealing with some of the most potent issues confronting us today.

COLLEEN VOJVODICH
Curator

THE ESTABLISHMENT OF CONTEMPORARY SOCIAL AND POLITICAL ART

I. MICHAEL DANOFF

From time to time, a particular form of art rises up and takes precedence in the minds and work of many artists, teachers, curators, and critics. Today the most compelling art is that which comments on social and political issues, a reflection of the primacy of these matters in many sectors of the culture at large. For example, the cover story of a recent issue of *Newsweek* (December 24, 1990) was about "pc": not the personal computer, but being politically correct as a dominant issue on campuses in the United States. Such art is not yet the art of the "establishment," and per-

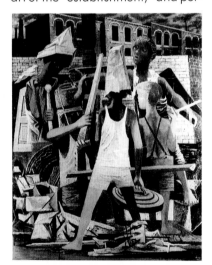

Fig. 1. Philip Guston, *Martial Memory*, 1941, oil on canvas, Saint Louis Art Museum, Eliza McMillan Trust Fund Purchase.

haps its artists never want it to be. But the growing wave of interest in social and political art has yet to crest.

Only in the past decade or so has it become acceptable for artists to be driven by subject rather than style, form, or method. As recently as 1984, when the Hirshhorn Museum and Sculpture Garden mounted an exhibition entitled *Content*, the concept was shocking to many. Although some artists still prefer to veil their focus on social and political issues, increasingly one is not doomed to lurking about the art world's margins as retribution for focusing on social and political subjects. In fact, artists today find their content to be so consuming that some are more dedicated to activism than to making objects of visual delectation.

The expression of social and political concerns is, of course, not new to art in Western Europe and the United States (see Hutton, pp. 74–82). One can cite Francisco Goya's *The Disasters of War*; Honoré Daumier's prints for *Charivari* (see p. 78, fig. 7); Käthe Kollwitz's prints about repression and rebellion; George Grosz's indictments of the German bourgeoisie; Pablo

Picasso's *Guernica*; Diego Rivera's murals that celebrate workers; Ben Shahn's expressions of social conscience; and the early work of Philip Guston, which reflected the mood of the Great Depression and world tumult instigated by the Nazis (fig. 1).

But Guston, like the other incipient Abstract Expressionists in the 1940s, came to abandon the representational image. Even though it was accepted that representational images were effective instruments for communicating social and political problems, such specific references proved too confining to convey the cosmic doom and gloom of recent history.

By the beginning of the 1950s, Abstract Expressionism was the discovered and enshrined Holy Grail of painting in the United States. The movement was understood by Harold Rosenberg and the majority of art historians as the first instance when American art conquered the Western industrial world.[1] Rather than American artists assuming they must work in a European tradition, for the first time artists from abroad studied and built on art created in the United States.

In the 1960s, new generations

of artists continued to work under certain assumptions for art-world success derived from Abstract Expressionism. Among these requisites were the abandonment of explicit social and political subjects and a dedication to nonrepresentation (with a few notable exceptions, such as Willem de Kooning). The teeter-totter principle was set in concrete: the higher the explicit subject matter, the lower the aesthetic quality.

Another tenet that arose in the 1960s can be found in the term "antisensibility," used by art dealer Ivan Karp.[2] He was referring to the work of Pop artists such as Andy Warhol (pp. 68–70) and Roy Lichtenstein, but his expression also applies to Minimal art, which reflected the same cultural values as Pop art. Pop and Minimalism mirrored U.S. post–World War II economic prosperity and productivity.[3] One finds in them industrial images, such as production-line repetition; industrial techniques of fabrication; and industrial materials, such as stainless steel or plastic (fig. 2). Warhol's studio was called the "Factory"; Lichtenstein stated that he "likes the style of industrialization."[4] Minimalist sculptor Donald Judd said, "Dams, roads, bridges, tunnels, storage buildings and various other useful structures comprise the bulk of the best visible things made in the century."[5]

The reflection of industrial productivity required that personal passion be no more pronounced in a work of art than in mechanical structures or a can of Campbell's soup. The concealment of personal passion—the pursuit of antisensibility—was at odds with communicating social and political convictions.

By the end of the 1960s, because of growing concern over race riots, assassinations, the war in Vietnam, and environmental pollution that resulted from the very industrial productivity the previous generation had celebrated, younger artists rejected the values of Pop and Minimalism. At the same time the gross national product took a downturn, and confidence in the economy was shaken. The late 1960s reflected the deep feelings of a troubled world, and it seemed to be a perfect moment for a glorious efflorescence of social and political art.

During the late 1960s and early 1970s, however, mainstream artists, schooled in Abstract Expressionism and admiring the achievements of Pop and Minimalism, expressed social and political statements obliquely at best. Most of their work took the form of Conceptual art, Earth art, and Antiform art. Conceptual and Earth art implied that the world was glutted with industrially manufactured objects, and that all an artist could do in good conscience was originate art as a concept rather than an artifact, or reshape earth already in place. Antiform art suggested that traditional ways of making, judging, and exhibiting art—and the society that engendered such traditions—were moribund.

Conceptual art, Earth art, and Antiform art were so indirectly social and political as to scarcely qualify for such a description. What was needed for social and political art to emerge was permission to employ the representational image and to be explicitly passionate, which evolved in the 1970s.

The art scene in the 1970s has been called "pluralist,"[6] not in the

sense that mainstream artworks represented cultural diversity, a much more recent phenomenon, but because of the principle of "personalism": if everyone does his or her "own thing," the art will look diverse. Historically, the most esteemed art has been strongly personal, the articulate visual expression of an individual's unique viewpoint. Even the artful impersonality of Lichtenstein or

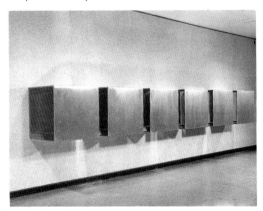

Fig. 2. Donald Judd, *Untitled*, 1966–68, stainless steel and Plexiglas, Milwaukee Art Museum, Purchase, Layton Collection.

Judd was an individual, personal expression. In the 1970s the personal was again drawn into the foreground of conscious concern. Unlike the personal gestures of Abstract Expressionism, however, there was little that was cosmic, mystical, or anguished in mainstream art of the 1970s; it was more self-centered, responding to a phenomenon evident throughout society at that time. Personalism became fashionable and was pursued through meditation, yoga, jogging, tennis, encounter groups, consciousness-raising peer groups, assertiveness training, health clubs, divorce, and other means all aimed to put one in touch with body and soul.

In most mainstream art of the 1970s, even that of artists who

grew up on Minimalism, personal sensibility was proclaimed rather than artfully concealed. Images abound that are eccentric, highly imaginative, or frankly heartfelt, and personalism is seen in the display of process and at times in the track of the artist's hand or the introduction of representational images.[7]

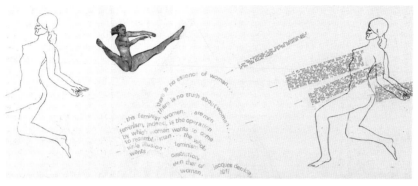

Fig. 3. Nancy Spero, *Notes in Time on Women II* (detail, panel seventeen of twenty-four), 1979, painting and typewriter collage on paper, collection of the artist.

Throughout the 1970s the representational image gradually reemerged, in part because of consumer preference, but also because of the gradual evaporation of the inviolate faith in abstraction, which did not readily communicate beyond a knowledgeable audience. In the mid-1970s so-called New Image artists like Susan Rothenberg demonstrated that the image could be used not only as a device on which to hang sophisticated abstractions but also as an expressive vehicle. By the end of the decade, artists such as Eric Fischl, David Salle, and Julian Schnabel were dubbed Figurative Expressionists for their highly personalized use of figurative images. Art had swung from anti- to pro-sensibility.[8]

Thus, in the 1970s, styles of art developed that enabled the display of strong feeling and the use of representational images — both conducive to social and political content. Such art was not immediately embraced, but some artists previously excluded began to be exhibited or written about more frequently, although rarely in the most prestigious galleries, museums, or periodicals. Those artists who depicted explicitly political subject matter, especially if they worked in traditional styles or if they were people of color, remained largely unsought, undesired, and generally unknown in mainstream contexts.

Leon Golub (pp. 32–35), for example, seemed a permanent outsider at first, due to his personal representational paintings that presented first mythological and then political images. As social and political art became more widely accepted, he was seen less as an outsider and more as a forerunner. Nancy Spero faced prejudicial categorization because she is a woman and because she chose formats that were not favored by the dominantly white-male art world: her works featured paper rather than canvas, stamped images, and unusual dimensions (fig. 3).

Matters of geography, medium, race, and subject influenced the recognition of artists such as Robert Colescott, who is black and works on the West Coast; Sue Coe, an Englishwoman (pp. 29–31); Robert Arneson, whose predominant medium is clay; Mike Glier, whose politically charged subjects range from white-male dominance to environmental disasters; and Ed Kienholz, whose linkage by some critics to Pop art and assemblage drew attention away from his extraordinarily potent social commentary.

Most of these artists worked in the historical traditions of social and political art, employing an overtly expressive approach that depended on the power of representational images and personal touch. But in the 1970s and early 1980s, this approach was still considered by many to be too retrograde. Social and political art that entered the mainstream in the 1980s was made by artists who addressed issues of consumerism and the mass media and who worked in nontraditional styles that had evolved during the 1960s. Part of the art world's comfort with this work came from its familiar nontraditional formats. These objects variously recalled Pop, Minimalism, and Conceptual art; some of the work even was dubbed "Neo-Geo."

By 1986 American art that focused on issues of consumerism was exhibited and purchased in European countries as well as at home. This phenomenon reflected the ascendancy of yuppies: articles, books, T-shirt mottoes, and jokes have been dedicated to them and their exaltation of materialism. Not surprisingly, issues of consumerism were compelling especially for artists working in the hyperactive New York art market.

R. M. Fischer, Robert Longo (pp. 53–55), Alan McCollum, Ashley

Bickerton, Peter Halley, Jeff Koons, and Haim Steinbach are among the mainstream artists whose paintings and sculptures referenced consumerism. Many of them used appropriation as direct testimony of their involvement with manufactured objects.[9] For example, Koons, who spent several years working as a commodities broker to earn money to fabricate the art he envisioned, began a series in 1980 entitled *The New*, which consisted of factory-fresh vacuum cleaners and floor polishers packaged in Plexiglas and illuminated with visible fluorescent bulbs (fig 4). Koons intended the works to operate on various levels and to appeal to both uninitiated and sophisticated art viewers. The encapsulated pieces show the beauty of manufactured objects and raise the frustrating paradox that to enjoy new things consumes the very newness that makes them so seductive.

Haim Steinbach's sculptures were made of store-bought objects juxtaposed on wall-mounted support structures designed by the artist. Steinbach has stated that his art has to do with "one's taking pleasure in objects and commodities . . . a stronger sense of being complicit with the production of desire, what we traditionally call beautiful seductive objects."[10] Steinbach was sincerely affected by the beauty of these manufactured goods presented on their altarlike mantels, but at the same time he questioned compelling materialism: however beautiful the shelves are, they are still shelves for consumer objects and vehicles for merchandising.

These artists were less interested in the aesthetics of manufactured products than they were in why these objects compel us, how they satisfy desires, and who establishes those desires. Other artists in the late 1970s explored related issues by appropriating photographic images rather than objects. They called attention to our society's addiction to advertising-controlled media such as television and magazines. The extent to which we have become a society of "couch potatoes" (as in the finale of the opening sequence of the TV series "The Simpsons")—sitting passively, seeking relaxation before these manipulative machines for consumerism—suggests that we feel most alive when we are plugged into the media. The media can seem more real than reality—hyper-real.[11]

In 1977 Richard Prince commenced a form of appropriation that has made him the progenitor of a generation of artists who re-present existing art images (Sherrie Levine and Larry Sultan also made major early contributions in this area). Prince rephotographed commercial advertising images that were hyper-real for him to the point that he wondered what the images imagined. For Prince, they possessed as much reality as the "real world," and were more than copies of the world. He understood the images to be about the wishful thinking of a generation manipulated by media and dominated by consumerism.

In the early 1970s Barbara Kruger (pp. 49–52) was immersed in an eleven-year career as a designer and photo editor at Condé Nast, whose publications include *Vogue*. By 1978 she started to produce "fine art" works, using appropriated photographs on which she superimposed texts. The issues she presented were often about power,

frequently about feminism, and her highly seductive visual technique was derived from the look of contemporary commercial advertising design. The physical appearance of her works highlights the exploitation of our desires by the media while the text counters that manipulation.

The works of Koons, Steinbach, Prince, and Kruger constitute a body of social and political art that might be called Post-Expressionist. Rather than drawing or painting to expose the artist's personal touch, Post-Expressionists use formats that include appropriation, photography, documentation, installation, and performance in varying combinations. Hans Haacke (pp. 36–38) has also been influential in this area, as have Jenny Holzer (pp. 43–45), Ronald Jones, and Alfredo Jaar. These artists and others working along similar lines were key to establishing a broad range of social and political concerns as acceptable subjects.

The formats in which these Post-Expressionist artists usually work

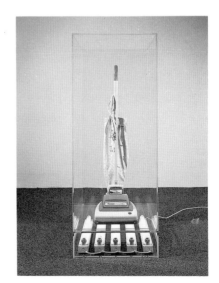

Fig. 4. Jeff Koons, *New Hoover Convertible*, 1980, one new Hoover Convertible, Plexiglas, and fluorescent lights, collection of Dr. Don and Mera Rubell, New York.

evolved from the contemporary art mainstream (i.e., Pop, Minimal, Conceptual art), which means that, whether the artists liked it or not, the formats required initiate knowledge for understanding. Those who are absorbed in the mainstream art world have difficulty keeping in mind that for most viewers, works of art even by artists like Holzer or Jaar are hard to apprehend as art and therefore do not readily convey the artist's vision. Of course it is highly rewarding to become acquainted with the vocabularies of the Post-Expressionists (and other mainstream contemporary artists as well). But art that does not demand specialized knowledge seems less interesting to most mainstream habitués. And although Holzer and Jaar tend more than many social and political artists to deal explicitly with their subjects, the majority of the Post-Expressionists lean toward the more implicit, still carrying forward the mainstream requirement since the days of Abstract Expressionism that shuns explicit social and political content.

Hans Haacke constructs installations that often combine appropriated material, photography, text, and documentation. His works confront corruption caused by political and financial greed and are often dense, complex, and pointed. His retrospective at the New Museum of Contemporary Art in New York (1986–87) may not have traveled in part because museums feared controversy.

Jenny Holzer was first recognized for her *Truisms*, a kind of guerrilla warfare in the realm of political conscience, which appeared as broadsides around New York. Many of the *Truisms* are

explicitly social and political, but increasingly Holzer's words have become more personal, some dealing with her recent motherhood. The aphorisms have appeared as sculptures on light-emitting diode (LED) boxes, and Holzer has also used more complex screens that allow a certain amount of animation. In the past few years she has revealed an extraordinary gift for site-specific installation, as demonstrated by her shows at New York's DIA Foundation (1989–90), the Guggenheim Museum (1989), and the prize-winning U.S. pavilion at the Venice Biennale (1990). Some of these included not only light boxes but benches and tomblike structures on which the statements were engraved.

Ronald Jones's suggestive works seduce the viewer through their craftsmanship and ambiguity. Once engaged, the viewer is powerfully affected when she or he discovers that (in one series) what seem to be re-creations of Modernist sculptures, such as those by Brancusi, are actually three-dimensional realizations of electron microscope photographs of the AIDS virus. This is not social and political commentary for the masses but for the contemporary art mainstream initiates who would not take seriously explicit social and political art. Other issues Jones has addressed include war and political injustice, and, like Jenny Holzer's, his works are fabricated and installation-oriented.

Alfredo Jaar grew up in Chile, where he studied architecture and film. Most of the photographs he uses he took himself, and they frequently concern the misfortunes of the marginalized. Jaar installs the

images in back-lit light boxes. To emphasize his interest in people at the periphery of society, Jaar often places the images at the edges of the light boxes, and sets the boxes at the borders of the gallery space. Jaar also regularly locates the photographs so that the viewer must look down on the figures. All of these practices are metaphors for the relation between the privileged and the underprivileged.

As the 1980s advanced, it became increasingly acceptable for artists to deal with social and political issues without being excluded from the mainstream.[12] Two important factors that helped create this environment were the women's movement and compelling new voices in the academic world (some women's, some not). Through the College Art Association, activism, cooperatives, and publications, feminism became a powerful force in the art world. It often was a way of thinking "in which the communication of information was not separate from the communication of emotion, in which the analysis of art was informed by intense advocacy."[13] Many feminists and other academics questioned art historical training that emphasized an artwork's sources and influences and an artist's biography as scarcely more than ends in themselves. The new art historians focused instead on experiential content—what seemingly is communicated from human being to human being—and on social implications such as class and gender.[14]

Today the most important phenomenon feeding the growth of social and political art is the emergence of voices from the shifting margins. Understandably, people of color and others

who have been ignored and repressed often deal with such inequities and their consequences in their art. The interaction of different cultural and aesthetic values, which previously had remained separate, has created a ferment. Guillermo Gómez-Peña, an artist as well as an eloquent writer and lecturer working through the San Diego–based Border Arts Workshop, writes that "The East Coast/West Coast cultural axis is being replaced by a North/South one" —meaning dominant white cultures to the north, and Latin American cultures to the south.[15] Borders are being crossed on every level, not only geographically but culturally and socially too. Gloria Anzaldua writes in her book *Borderlands: The New Mestiza*: "The actual physical borderland that I'm dealing with in this book is the Texas—U.S. Southwest/Mexican border. The psychological borderlands, the sexual borderlands and the spiritual borderlands are not particular to the Southwest."[16] (The film and television series *Alien Nation* were limited but intriguing metaphors for this growing interchange.)

South of the U.S. border, artists occupy a central place in society, often as social commentators. This living tradition continues in the work of many Mexican-American artists, such as Rupert García, whose work for over twenty years has invariably been driven by social concerns and politics (fig. 5). Gómez-Peña says that it is a "quintessential Latin American phenomenon [for] political and artistic thought and discourse [to be] inevitably intertwined," and that this phenomenon is alive in Chicano communities.[17]

The presumably factual and

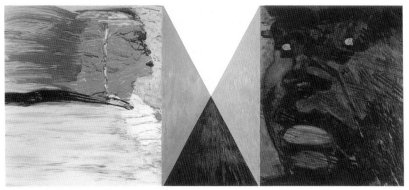

Fig. 5. Rupert García, *Shadow Nose History; Diaspora African*, 1988, mixed media on canvas, courtesy of the artist and Rena Bransten Gallery, San Francisco.

inviolable history of the world written from the perspective of white Europeans and Americans is undergoing radical revision. Viewpoints of minorities and other disempowered groups have come to the center and are making a necessary and equal contribution. Barbara Kruger and Phil Mariani write in the introduction to their 1989 anthology *Remaking History*: "The past several years have seen the development of alternative histories, recoveries of neglected and 'forgotten' cultures and the recuperation of names and faces."[18] A striking example of the revisionist approach can be seen in the writing of Cornel West:

> We now live forty-four years after the age of Europe—that is, an unprecedented world-transforming historical period (1492–1945) in which those countries that reside between the Ural Mountains and Atlantic Ocean discovered new lands, subjugated those peoples on those lands, degraded the identities and cultures of non-European peoples (Africans, Asians, Latin Americans, and indigenous peoples), and exploited laborers of both European and non-European descent.[19]

Although artists from culturally diverse backgrounds are reaching larger audiences than ever before, exhibitions intended to document their art and its content have not always enjoyed distinction. Most

curators and museums are still feeling their way. Some shows focusing on "Hispanic art" lumped together artists and cultures with what now seems insufficient sensitivity. One such exhibition was *Hispanic Art in the United States: Thirty Contemporary Painters and Sculptors*, originated in 1987 by the Museum of Fine Arts, Houston. In 1989 the Georges Pompidou Center in Paris mounted the even less discriminating *Magicians of the Earth*, which attempted to be a truly international contemporary art show, putting the traditional work of aborigines alongside, for example, that of Alfredo Jaar. (The Museum of Modern Art's exhibition *Committed to Print* [1988], curated by Deborah Wye, contained a great deal of social and political art, but its focus was printed formats.)

Over the past few years several exhibitions have profited from a narrower focus. These include one-person shows, such as the one of Robert Colescott's paintings (fig. 6) organized by the San Jose Museum of Art (1987), and group shows such as *The Appropriate Object* (Albright-Knox Art Gallery, 1989), which dealt with how artists working in mainstream contemporary styles

enrich their art with what is particular to their cultural background when that background is other than mainstream (the artists in the show were all black). *The Appropriate Object* also raised the issue of ghettoization—whether it is preferable for black artists (or women, or Mexican-Americans, or others) to proclaim what is distinctive to them or blend into the shrinking mainstream. In 1990 the New Museum, the Studio Museum of Harlem, and the Museum of Contemporary Hispanic Art jointly organized *The Decade Show*, a retrospective of art of the 1980s and issues of cultural diversity. The show broke ground by joining diverse institutions and curatorial viewpoints and repre-

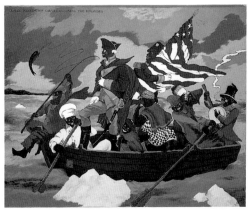

Fig. 6. Robert Colescott, *George Washington Carver Crossing the Delaware: Page from an American History Textbook*, 1975, acrylic on canvas, collection of Robert H. Orchard, St. Louis.

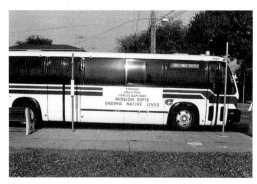

Fig. 7. Hachivi Edgar Heap of Birds, *Mission Gifts*, 1990, transit poster commissioned by the San Jose Museum of Art.

senting them for the varied audiences of the three museums.

Political and social issues are so potent for many people today that a surprising number of artists find engaging in activism more satisfying than producing traditional art forms. This position was recently stated by students at a symposium held at the San Francisco Art Institute (August 13, 1990). Elsewhere, as at the Arts and Social Change division of San Francisco's New College of California School of Humanities, students may take courses in "cultural organizing."

The blending of interests in activism and art making is manifested in many publications. Among them are Lucy Lippard's 1984 anthology, *Get the Message?: A Decade of Art for Social Change*; the 1985 anthology *Cultures in Contention*,[20] which brings together writings on culture and politics, often activist in their orientation; and the 1990 anthology *Reimaging America—The Arts of Social Change*,[21] which expresses a particular sensitivity to questions of cultural diversity. Arlene Raven's 1989 anthology on public art, *Art in the Public Interest*, begins with an essay on Greenpeace, one of whose projects appears as the cover illustration. This anthology amply demonstrates that activism is changing the face of public art; the first words in the introduction are, "Public art isn't a soldier on a horse anymore."[22]

Books such as Edward Said's *Orientalism*, a history of the concept of the "Oriental" as the dominated "other"; James Clifford's *The Predicament of Culture: Twentieth-Century Ethnography, Literature, and Art*, a set of essays uniquely combining aspects of anthropology, art history and criticism, and biography; and

Trinh T. Minh-Ha's *Woman, Native, Other: Writing Postcoloniality and Feminism*, which is extremely insightful on the relation between language, voice, and identity, are discussed by many members of the art world as avidly as the aesthetics of the shaped canvas were earlier.

Some artists, like Hachivi Edgar Heap of Birds, move easily between the creation of more traditional contemporary art, such as abstract paintings derived from forms and colors seen in clouds, mountains, and leaves, and explicitly social and political works. An example of the latter is a public art project commissioned by the San Jose Museum of Art in 1990. Transit boards appeared on buses in Santa Clara County and referred to the major causes of death of Native Americans in the San Jose area (fig. 7).

Other artists address any number of social and political issues such as feminism, border culture, media prejudice, Native American concerns, ecology, and ecofeminism. But perhaps the most visible activism in the art world today is in response to the AIDS crisis. Because the subject is highly charged, its appearance in art often raises the question of whether such cultural expressions are art or activism. For example, are the videos of the New York–based collective Testing the Limits works of art or traditional documentation? Similarly, is Douglas Crimp's recently published *AIDS Demographics*, a history of the New York chapter of ACT UP illustrated with their powerful posters, about activism or art? Are the signs that Edgar Heap of Birds places in cities activism or art? Are Jenny Holzer's early *Truisms* any more or less art

when shown in the "frame" of an art museum? The feeling that art and activism can be united is growing and depends on how an artist chooses to define himself or herself as an artist. Ultimately it is fruitless to designate boundaries for what is or is not art. Decades ago E. H. Gombrich, a revered and classically trained art historian, commenced his survey text *The Story of Art*: "There really is no such thing as Art. There are only artists."[23]

The history of the rise of social and political art to prominence, and the intertwined history of cultural diversity and its relationship to the mainstream, are complex processes still under development.[24] In this situation, where long-held assumptions about aesthetic value are made uncertain, the criteria for determining quality are perplexing.[25] The question of quality remains important because it is a measure for what is included and excluded in art museum exhibitions and permanent collections and for what gets written about in publications. The curator and writer's concept of quality is, in effect if not intention, a filter. Moreover, the concept of aesthetic merit can be used to keep works by people of color, women, and other traditionally disenfranchised members of the art community from the attention they deserve. When curators and critics rely on systems of judging art that have been instilled by training and refined by practice, such systems become gospel, and calling them into question is threatening.

For decades, the artists who grabbed the art world's attention most quickly were those who built on inherited and accepted practices by finding a way to be new and

different in style and format. In the best instances, these artists also made work authentically and deeply expressive of themselves. At present, the emphasis on new styles and formats retains a validity for some art, but it is not encompassing or definitive. More captivating and challenging in much art today is the opportunity to expand one's understanding about issues such as environmental crisis, economic exploitation of marginalized peoples, and repressive policies toward Native Americans.

Although values are undergoing an overdue reevaluation, it is not necessary to abandon criteria for assessing the quality of works of art. One major indication of excellence is how effectively the subject is communicated. Obviously the choice of subject by itself cannot assure that a work of art will succeed; this depends on how its subject is conveyed. Here innovation may play a role, but more as a means than an end. Comparison and contrast, essential ingredients in judgments of quality, are still used to distinguish between works that are empty bombast and cheap sentimentality and those that powerfully communicate a message.

Familiarity with numerous examples of art and with the issues addressed are essential in assessing the effectiveness of a particular work. Understanding the subject in its cultural and historic context is essential as well (much as iconographic studies decode the art of earlier cultures and periods such as Florence in the quattrocento).

But what about the relation of established canons of quality to the role of the message itself in determining value? When issues are so charged, one must question

whether one's response to a work of art can exclude its subject matter. Most viewers do not likely make the same aesthetic judgment about art that advocates child molestation and art that communicates its tragedy. Subject matter itself—particularly when controversial—often is a factor in the viewer's determination of a work's excellence. To allow content to be a factor, of whatever importance, is to acknowledge that socially and politically oriented art profoundly challenges us.

NOTES

1. Harold Rosenberg, "Parable of American Painting," in *The Tradition of the New* (New York: McGraw Hill, 1965), pp. 13–22.
2. Ivan Karp, "Anti-Sensibility Painting," *Artforum* 2, no. 3 (September 1963), pp. 26–39.
3. For an extensive treatment of this concept, see I. Michael Danoff, *Emergence and Progression: Six Contemporary American Artists* (Milwaukee: Milwaukee Art Museum, 1979).
4. "Roy Lichtenstein: An Interview," in John Coplans, *Roy Lichtenstein* (Pasadena, Cal.: Pasadena Art Museum, 1967), p. 12.
5. Donald Judd, "Twentieth Century Engineering," *Arts Magazine* 49, no. 2 (October 1974), p. 62.
6. See, for example, Jane Livingston's introduction to Ed McGowin's *True Stories* (Washington, D.C.: Corcoran Gallery of Art, 1975) and Linda Cathcart's introduction to *Painting in the Seventies* (Buffalo: Albright-Knox Art Gallery, 1978).
7. Many of these concepts and some of the wording regarding art in the 1970s appeared in my introduction to *Art in Our Time: HHK Foundation for Contemporary Art, Inc.* (Milwaukee: HHK Foundation for Contemporary Art, Inc., 1980), n.p.
8. Actually, even in the mainstream the representational image did not disappear with the advent of Abstract Expressionism. The representational image was important in de Kooning's work and was, of course, basic to Pop art and Photorealism.
9. Appropriation was an extraordinarily influential concept for many artists in the 1980s.

Appropriation itself has a long history, beginning with Cubist collage. What usually has been appropriated includes manufactured objects and remnants from the media (pieces of newspaper, for example), indicative of a century-old fascination with consumer objects. For a full discussion, see I. Michael Danoff, *Jeff Koons* (Chicago: Museum of Contemporary Art, 1988), pp. 16–19.

10. Peter Nagy, moderator, "From Criticism to Complicity," *Flash Art* 129 (Summer 1986), p. 46.

11. The cult figure writing about hyper-realism is Jean Baudrillard: "The very definition of the real has become: that of which it is possible to give an equivalent reproduction. . . . The real is not only what can be reproduced, but that which is always already reproduced. The hyperreal . . . [which] is entirely in simulation." See *Simulations* (New York: Semiotext(e), 1983), pp. 146–47.

12. This phenomenon certainly has been occurring in popular music. Now social and political themes are heard not only in recordings by Holly Near or Sweet Honey in the Rock (which Tower Records segregates in a small "women's music" section); Suzanne Vega and Tracy Chapman address some of the same issues in songs that reach the top of pop charts.

13. Donald Kuspit, in *Feminist Art Criticism: An Anthology*, ed. Arlene Raven, Cassandra L. Langer, and Joanna Frueh (Ann Arbor, Mich.: UMI Research Press, 1988), p. ix.

14. Examples of breakthrough writings included Leo Steinberg, *Other Criteria: Confrontations with Twentieth Century Art* (New York: Oxford University Press, 1972); Robert Rosenblum, *Modern Painting and the Northern Romantic Tradition* (New York: Harper and Row, 1975); Max Kozloff, "American Painting during the Cold War," *Artforum* 11, no. 9 (May 1973), pp. 43–54; Eva Cockcroft, "Abstract Expressionism, Weapon of the Cold War," *Artforum* 12, no. 10 (June 1974), pp. 39–41; Lucy Lippard, *Get the Message?: A Decade of Art for Social Change* (New York: E. P. Dutton, 1984); and T. J. Clark, *The Painting of Modern Life: Paris in the Art of Manet and His Followers* (Princeton, N.J.: Princeton University Press, 1986).

15. Guillermo Gómez-Peña, "Border Culture: The Multicultural Paradigm," in *The Decade Show: Frameworks of Identity in the 1980s* (New York: Museum of Contemporary Hispanic Art, New Museum of Contemporary Art, and Studio Museum in Harlem, 1990), p. 93.

16. Gloria Anzaldua, *Borderlands: The New Mestiza* (San Francisco: Spinster/Aunt Lute, 1987), n.p.

17. Guillermo Gómez-Peña, "A New Artistic Continent," in *Art in the Public Interest*, ed. Arlene Raven (Ann Arbor, Mich.: UMI Research Press, 1987), p. 113.

18. Barbara Kruger and Phil Mariani, eds. *Remaking History*, Discussions in Contemporary Culture, no. 4 (Seattle: Bay Press, 1989). That such ideas are deeply affecting what remains of the mainstream is evidenced by this anthology, occasioned by papers delivered at one of a series of conferences sponsored by the DIA Foundation, which until recently had been focused on avant-garde but mainstream contemporary art. It also is noteworthy that a provocative series of anthologies, *Documentary Sources in Contemporary Art*, about the style and content of social and political art and issues related to marginalization has been issued by the New Museum of Contemporary Art. The volume most consistently pertinent to the issues in this essay is Russell Ferguson, Martha Gever, Trinh T. Minh-ha, and Cornel West, eds., *Out There: Marginalization and Contemporary Cultures* (New York: New Museum of Contemporary Art; Cambridge, Mass.: MIT Press, 1990).

19. Cornel West, "Black Culture and Postmodernism," in Kruger and Mariani, *Remaking History*, p. 87.

20. Douglas Kahn and Diane Neumaier, eds., *Cultures in Contention* (Seattle: Real Comet Press, 1988).

21. Mark O'Brien and Craig Little, eds., *Reimaging America—The Arts of Social Change* (Philadelphia: New Society Publishers, 1990).

22. Raven, *Art in the Public Interest*, p. 1.

23. E. H. Gombrich, *The Story of Art* (New York: Phaidon, 1966), p. 5.

24. Lucy Lippard is to date the most important writer regarding social and political art, although she makes no secret of her preference for "third-stream mediums." *Get the Message?* provides important historical information regarding social and political art, such as "Cashing in a Wolf Ticket," pp. 304–14, and "Hot Potatoes: Art and Politics in 1980," pp. 161–72. Lippard's most recent book, *Mixed Blessings: New Art in a Multicultural America* (New York: Pantheon, 1990), is a superb resource for a great variety of art that has had more than its share of marginalization.

25. Much of what follows regarding quality appeared in I. Michael Danoff, "Art and Activism," *Artweek* 21, no. 37 (November 8, 1990), pp. 21–23.

CATALOGUE OF

THE EXHIBITION

JOHN AHEARN

JEAN-MICHEL BASQUIAT

JONATHAN BOROFSKY

SUE COE

LEON GOLUB

HANS HAACKE

KEITH HARING

JENNY HOLZER

ANSELM KIEFER

BARBARA KRUGER

ROBERT LONGO

ROBERT MORRIS

TOM OTTERNESS

CINDY SHERMAN

ANDY WARHOL

DAVID WOJNAROWICZ

David Cateforis and **Michelle Meyers** are doctoral candidates in art history at Stanford University and curatorial assistants at the Anderson Collection in Menlo Park, California.

JOHN AHEARN

John Ahearn was born in Binghamton, New York, in 1951.
He received a B.F.A. from Cornell University in 1973. He
lives and works in the Bronx, New York.

John Ahearn's freestanding and relief sculptures are life casts of his neigh-bors in the South Bronx, a poor, predominantly Hispanic and black neighborhood in New York City, far removed from the center of the art world. Ahearn often casts his subjects on the street, where curious observers occasionally become volunteers. He then recreates the likenesses in his studio. Working from the plaster cast and accompanying Polaroid photographs, he remains as faithful as possible to clothing, skin color, and personal eccentricities.

The sculptures are exhibited, individually or in groups, on building facades in the South Bronx as well as in galleries and museums. As a result, they have two lives. When displayed in the streets of the South Bronx, the works affirm community and individual identities. In contrast, in museums and galleries they confound the stereotypes white upper-middle-class gallery-goers tend to impose on poor nonwhites, and draw attention to cultural differences. As one critic has noted, Ahearn's works are "charged with the sociology of the streets."[1] This sociology, however, is not necessarily one the art-world audience expects to see. Ahearn's streets are not rife with violence or destruction. Instead they are often filled with exuberant and playful children. This world is spirited and lively; these figures suggest strength and the ability to survive. One can almost hear the hopeful sounds of the streets emanating from the silent gallery walls.

Back to School is composed of five relief sculptures and was made in 1985 with the assistance of Rigoberto Torres. A version of the work, illustrated here, was installed that year on a wall at Walton Avenue and 170th Street in the South Bronx, not far from Public School 64, where it still can be seen. Combined, the five sculptures create a familiar after-school scene of neighborhood adults and children. In "Titi in Window" a heavyset woman wearing a bright blue apron leans out her apartment window, her chin resting on her hand. She looks down, observing the street with interest and affection. Below her, various figures are engaged in activity, individually and in pairs. In the Broad Foundation version (not illustrated), "Thomas" runs cheerfully through the scene, looking past the viewer.[2] His brightly colored basketball shirt, number 44, hints at future hopes and the means by which some youngsters escape the ghetto. The figure of "Jay with Bike" is more reflective. A boy similar in age to Thomas, he pauses in a gesture that mimics that of Titi above, gazing at the viewer directly and thoughtfully. Have you really been invited? he appears to ask. Do you belong?

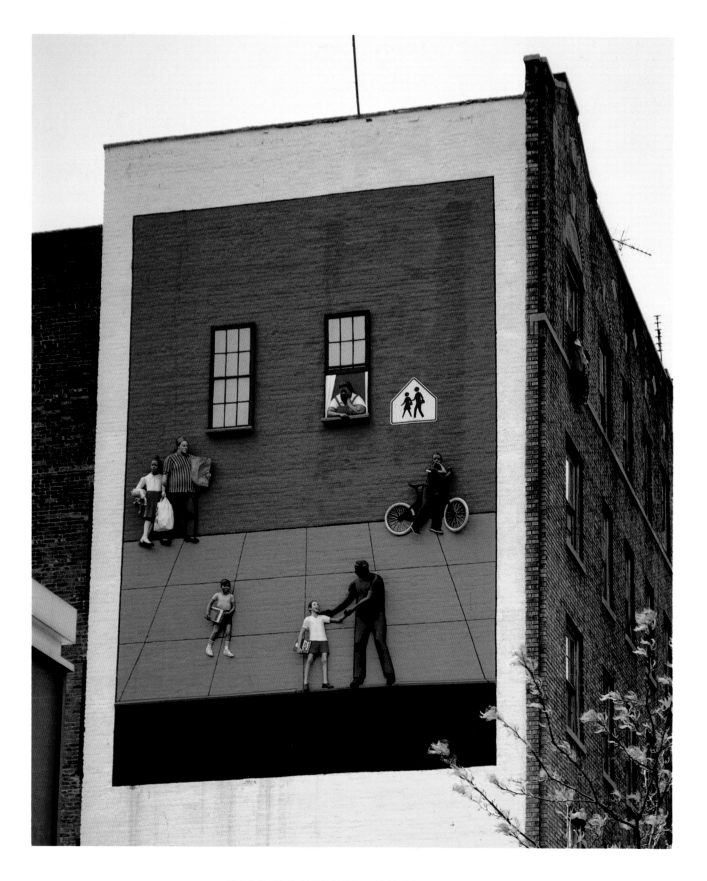

BACK TO SCHOOL 1985–86

five sculptures; mixed media

permanent outdoor installation in the South Bronx

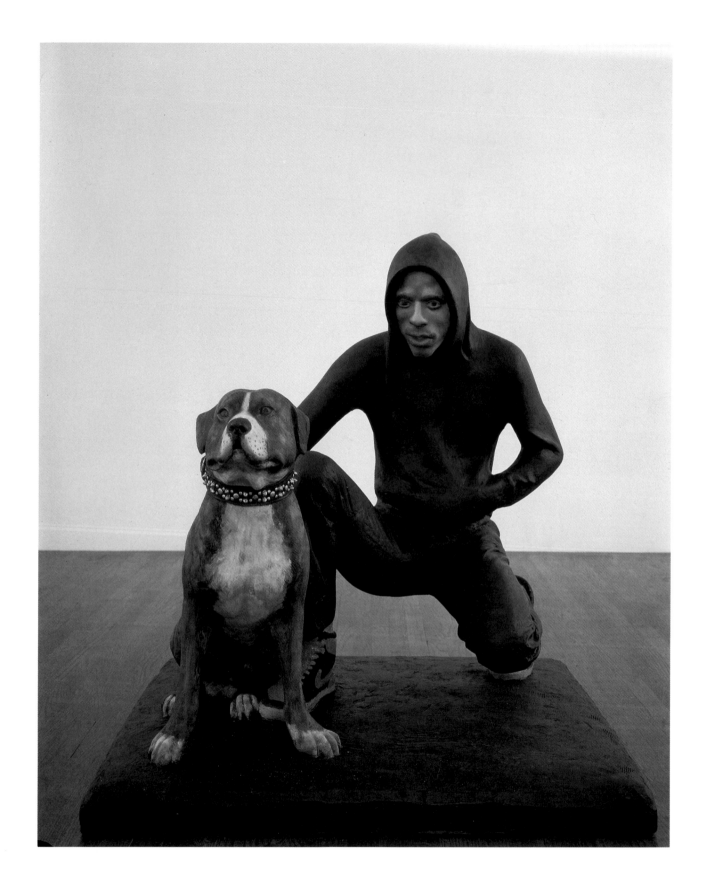

TOBY AND RAY 1989
oil on fiberglass
47 × 43 × 39

In "Maggie and Connie" a pregnant woman and a young girl return from the store. Carrying heavy bags bulging with supermarket goods, the woman walks solemnly, her eyes cast down. Her dark slacks and simple shirt contrast with the young girl's fancy white blouse, red pleated skirt, and shiny black pumps. The girl holds a pink baby doll and gazes at us with a vague smile that seems to seek assurance. Finally, in "Kido and Ralph" a young boy, school-book in hand, is gently cautioned by the school grounds superintendent.

Toby and Ray, a more recent work, is darker and more ambiguous. The freestanding sculpture depicts a slender black-hooded figure crouching next to a dog outfitted with a metal-studded leather collar. From the side or rear the pose can be read as aggressive and perhaps hostile, or as one of rest. From the front, however, the young man seems thoughtful or expectant, and his dog patiently awaits his command: they are clearly a team. The one spot of bright color is given to the man's bold red high-tops, which act as both a formal device and a significant cultural marker. The plinth on which the tableau rests forms the street within the scene and serves as a traditional pedestal.

MM

NOTES

1. Kay Larson, "John Ahearn," *New York* 19, no. 46 (November 24, 1986), p. 77.

2. *Back to School* takes its title from the figure of a young boy carrying school books included in the South Bronx installation. In the version of the work in the Broad Foundation collection, Ahearn has replaced this figure with that of "Thomas."

FOR FURTHER READING

Institute of Contemporary Art. University of Pennsylvania. *Investigations 12: John Ahearn with Rigoberto Torres: Sculpture.* Philadelphia, 1985.

Nelson-Atkins Museum of Art. *John Ahearn.* Kansas City, Mo., 1990.

JEAN-MICHEL BASQUIAT

Jean-Michel Basquiat was born in Brooklyn, New York, in
1960. He died in Manhattan in August 1988.

Jean-Michel Basquiat's career was as brilliant as it was brief. Bursting onto
the New York art scene during the explosion of graffiti art and Neo-
Expressionism in the early 1980s, he rapidly ascended into the international
limelight. Then, just as quickly, he was gone, dead of an apparent heroin
overdose at the age of twenty-seven. In the wake of his tragic and untimely
passing, many saw Basquiat as an avant-garde martyr for the 1980s, an
inverse van Gogh, killed by too much success, too soon.

Born in Brooklyn of a Haitian father and a Puerto Rican mother, Basquiat
was raised in middle-class surroundings against which he subsequently
rebelled. After being expelled from high school, he began a graffiti assault on
the walls of lower Manhattan, signing his brief, somewhat ominous texts
(SAFE PLUSH HE THINK) with the tag SAMO, followed by a copyright sym-
bol. SAMO's oracular messages caught the attention of the downtown art
world, and Basquiat was soon invited to participate in exhibitions of the
emerging graffiti art movement. Abandoning his SAMO persona, Basquiat
took up the paintbrush and within a few years was showing regularly in
New York, Los Angeles, Zurich, Rome, and Tokyo. International collectors
lined up to buy his aggressive African- and Voodoo-inspired "primitivist"
paintings, executed with childlike impulsiveness in bright, bold colors and
featuring grinning totemic figures, cars and skulls, arrows and crowns, num-
bers and words.

But Basquiat remained an outsider, a marginalized black artist in the
white art world. His achievement was to thrust the reality of the tenuous
status he shared with other African-Americans before the art establishment
so that it could not be ignored. Many aspects of Basquiat's primitivism were
sharply critical, particularly his use of language. Basquiat employed words in
his paintings in a fragmentary and often incomprehensible fashion, crossing
them out, misspelling them, repeating them until they were drained of mean-
ing. His words are "not to be read, but to be stared at, uncomprehendingly,
like an illiterate."[1] As Greg Tate reminds us, slaves were once forbidden liter-
acy by law on the grounds that it would make them rebellious.[2] Literacy tests
are still employed sporadically in the South to discourage poorly educated
blacks from voting. Basquiat's use of words reminds the literate viewer that
political power comes with the control of language.

In *Beef Ribs Longhorn* (1982), Basquiat jumbled phrases from the white
worlds of commodities exchange, government bureaucracy, and the U.S. Con-
stitution, deconstructing the coherent claims to authority these words were

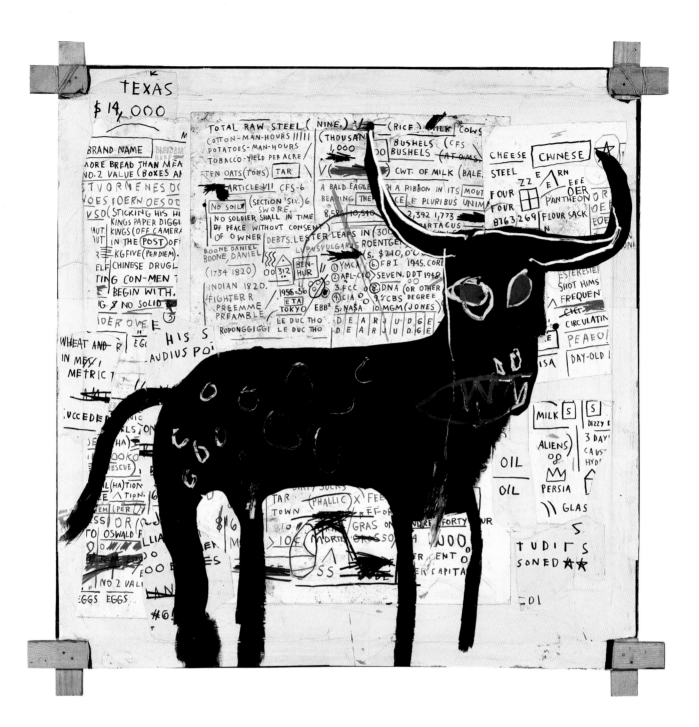

BEEF RIBS LONGHORN 1982

acrylic and mixed media on canvas

60 × 60

EYES AND EGGS 1983

acrylic and collage on cotton drop cloth

119 × 97

crafted to carry. The pitch-black steer painted over this field of linguistic collage is not only a future side of beef but might stand for the black person as chattel — a dehumanized, commodified body to be bought and sold.

Basquiat depicted blacks incessantly not only to underscore their infrequent representation in art, but also to make visible the wider social marginalization of African-Americans. In *Eyes and Eggs* (1983), Basquiat presents with bitter humor the enormous image of a pop-eyed, black short-order cook. The epic scale of the 10-by-8-foot painting throws into relief the lowly status of its subject. That status is reinforced by the disposable commercial drop cloth on which the image is painted and by the footprints that pelt its surface; this man has been literally walked all over. *Eyes and Eggs* at first provokes a chuckle and then a less comforting awareness of the economic exploitation and disempowerment of blacks, who are crowded into low-paying, menial service jobs.

A makeshift feeling, typical of Basquiat's work, is created by the visible wooden stretcher and crude collage of *Beef Ribs Longhorn* and the hinged drop-cloth panels of *Eyes and Eggs*. Basquiat lays down his images on surfaces that are tentative and unstable, and the images themselves, for all their bold, graphic presence, appear in the end flat, impermanent, even ghostlike. Basquiat's paintings structurally embody the same sense of marginality and transience conveyed by their subjects. As objects the paintings are intensely present, and yet they also seem remote and untouchable, like the painter himself. The tragic lessons of Jean-Michel Basquiat's life ultimately shape our understanding of his art and become inextricably mixed with its content.

DC

NOTES

1. Catherine Liu, "The Umbilicus of Limbo," *Flash Art* 146 (May/June 1989), p. 103.
2. Greg Tate, "Nobody Loves a Genius Child," *Village Voice* 34 (November 14, 1989), p. 33.

FOR FURTHER READING

McGuigan, Cathleen. "New Art, New Money: The Marketing of an American Artist." *New York Times Magazine*, February 10, 1985, pp. 20–35, 74.
Vrej Baghoomian, Inc. *Jean-Michel Basquiat*. New York, 1989.

JONATHAN BOROFSKY

Jonathan Borofsky was born in Boston in 1942. He received
a B.F.A. from Carnegie Mellon University in 1964 and an
M.F.A. from Yale University in 1966. In 1964 he studied
figure modeling at the Ecole de Fontainebleau in France. He
currently lives and works in Venice, California.

For the past fifteen years Jonathan Borofsky has been examining a series of archetypal figures and objects in large multi-media installations. Individual works are numbered to correspond with the artist's continuing activity of counting to infinity. Borofsky's figures are contradictory representations of the artist's self; thus, they can be situated within the Surrealist tradition. Yet the presentation of his works, which often includes sound, viewer participation, and wall drawings, suggests a greater debt to Happenings and graffiti.

Two of Borofsky's earliest and best-known archetypes are Hammering Man and Man with a Briefcase. Together they reflect his exploration of the artist's ambiguous role in society and the enigmatic activity of producing art. Like Borofsky's other archetypes, each includes its opposite.

Originally based on a photograph that Borofsky borrowed from an encyclopedia of a Tunisian shoemaker striking a shoe, Hammering Man has come to symbolize labor and the artist as producer/worker. Borofsky emphasizes the activity of the figure, but he has pointed out that the word "strike" has contradictory connotations: to make or produce, and to refuse to work.[1] The figure also suggests the conflict between the powerful and persistent notions of the artist as a God-like creator of intangibles such as truth, wisdom, and knowledge and as a craftsman/producer of material artifacts. Borofsky has illustrated this paradox by juxtaposing the Hammering Man with a scene from Michelangelo's *Creation*.

Man with a Briefcase began as an image of an artist carrying his drawings to galleries and museums. Conversely, the work represents a corporate businessman, who by acquiring a work of art transforms it from the record of a creative act into a commercial product.

Political situations—especially the arms race and political violence against individuals—are also central themes running through Borofsky's work. In *Male Aggression Now Playing Everywhere at 2,968,937* (1986), which addresses a subject he has examined since 1981, Borofsky uses humor and caricature to underscore the folly and danger of the arms buildup by associating sexual potency with military might. The archetype consists of a nude male figure whose erect penis has been replaced by a club, a knife, an arrow, a gun, and a missile. These are arranged hierarchically, with the simplest

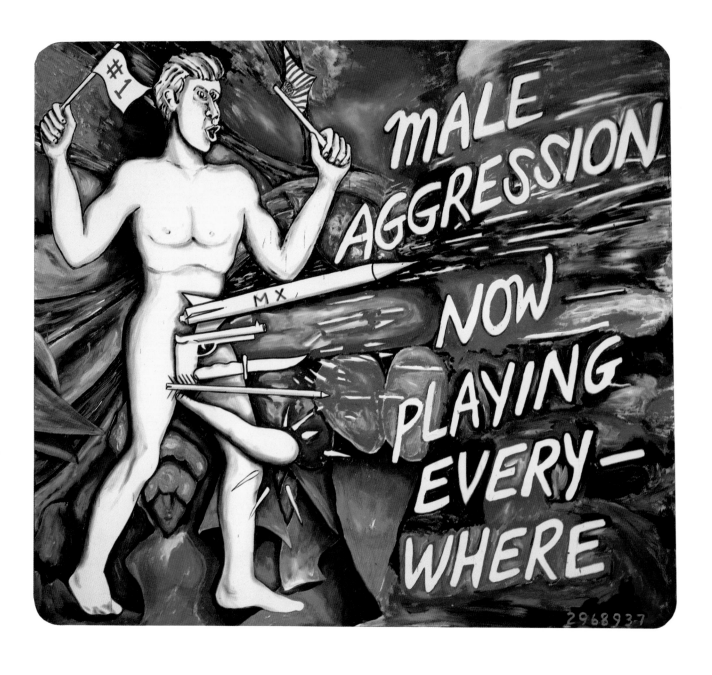

MALE AGGRESSION NOW 1986
PLAYING EVERYWHERE AT 2,968,937 acrylic on canvas
130 × 144

weapon at the bottom and the most sophisticated weapon at the top. Borofsky's association of aggression with a male figure is significant, for in other self-portrait archetypes he has allowed both the male and female sides of himself to emerge. Earlier versions of the male-aggression paintings included a sports car among the phallus substitutes, and the figure more closely resembled Borofsky's repeated caricature of himself as wide-eyed and hairless, with an exaggerated forehead and chin. In the work numbered 2,968,937 the figure is less recognizable as Borofsky, the car has disappeared, and the missile, which has been enlarged, is clearly identified as an MX. The figure is waving a small American flag and another flag inscribed "#1," a reference to the United States' assumption of superiority in the arms race with the Soviet Union. By evoking movie-theater announcements in the title, Borofsky draws attention to the manner in which film and television reinforce attitudes of macho superiority, but suggests that in these same media the battle against such opinions should be waged. MM

NOTES | 1. Mark Rosenthal, "Jonathan Borofsky's Modes of Working," in *Jonathan Borofsky*, by Mark Rosenthal and Richard Marshall (New York: Harry N. Abrams, 1984), p. 19.

FOR

FURTHER | Hayden Gallery. Massachusetts Institute of Technology. *2,699,475— Jonathan Borofsky: An Installation*. Cambridge, Mass.: MIT Press, 1980.

READING

SUE COE

Sue Coe was born in Tamworth, Staffordshire, England, in 1951. She grew up in London and attended the Chelsea School of Art as a teenager. From 1970 to 1973 she studied at the Royal College of Art. She moved to New York in 1972.

With desperate urgency, Sue Coe confronts the unpleasant realities of life under late twentieth-century capitalism. Poverty, homelessness, drug abuse, sexism, rape, vivisection, racism, apartheid, political repression, and nuclear proliferation are some of the topics she has addressed with uncompromising directness in her art. Although she is driven by leftist and feminist convictions, Coe considers herself a Social Realist rather than a political propagandist, pointing out that her goal has always been to document injustice and make information available to people so that they can act on it.[1]

Since 1972 Coe has provided illustrations for the op-ed page of the *New York Times*, has contributed to a wide range of other publications, and has illustrated two books. *How to Commit Suicide in South Africa* (1983),[2] a collaboration between Coe and journalist Holly Metz, documented the history of atrocities under apartheid. *X* (1986),[3] combining illustrations and poems by Coe with a text by Judith Moore, chronicled the life and death of civil rights leader Malcolm X.

Coe favors the printed page for its ability to reach the working class, normally absent from the elitist spaces of art museums and galleries. In seeking to expose to a wide audience the realities of injustice, oppression, and degradation, Coe participates in the critical tradition of protest art that stretches from Goya and Daumier to Käthe Kollwitz, Otto Dix, George Grosz, William Gropper, Philip Evergood, and the Mexican muralists. Like them, she is known primarily for the content of her work rather than its aesthetics. But in Coe's best pieces there is a formal power that dramatically heightens the impact of the content.

Such is the case with *The Children Are Going Insane* (1983), a wall-size drawing that pictures a malevolent nocturnal world of violence, desperation, and dissipation in the heart of the ghetto. This nightmarish scene is rendered in jet blacks and murky grays punctuated by splashes of blood red and bursts of harsh light that reveal jagged buildings and angular bodies. Embodied in a text that trips in lurid red fragments down the surface of the drawing is the bleak poetry of these streets: THE CHILDREN ARE GOING INSANE / EVERYTHING TAKES PLACE AT NIGHT / THE NIGHT IS RED.

Coe's use of text and collaged flat articles, such as playing cards and a news photo of a mugging, creates perceptual tension between the flat, literal existence of words and objects and the spatial illusionism of the image. The work's spatial integrity is also violated by unnaturally rapid shifts in scale

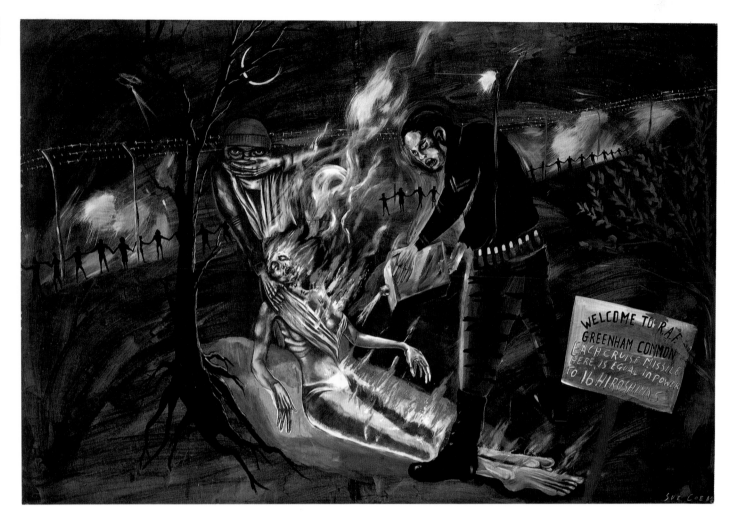

WELCOME TO R.A.F. GREENHAM COMMON 1984

mixed media and collage on paper

50 × 73 ½

between the large central figures—a slick, card-playing pimp, a howling cat, and a devilish dog dying of a bloody stab wound — and diminutive background personages. This jarring lack of cohesion expresses what Donald Kuspit has termed a "pathological vision of human and social disintegration" in Coe's art.[4]

Less formally adventuresome but offering an even more explicit vision of nocturnal violence is *Welcome to R.A.F. Greenham Common* (1984). Here a swooning, emaciated woman (women are frequently seen as victims in Coe's art) is being burned alive by militaristic thugs who douse her with gasoline. A bloodstained sign identifies Greenham Common, in Berkshire, England, site of a U.S. Air Force base that houses cruise missiles. Since 1981 the base has seen frequent antiwar demonstrations and civil disobedience by women from around the world who have converged on Greenham Common and set up camps along the perimeter fence. These women have routinely attempted to interfere with the deployment of missiles, often being arrested and imprisoned. In Coe's painting they are pictured in the background as a human chain, protesting witnesses to the horrific immolation occurring on the viewer's side of the "security" fence.

These watchful figures indicate that works like *Welcome to R.A.F. Greenham Common* embody, for all their pessimism, a degree of hope. Coe has visited the activist community at Greenham Common and feels that "it's created a consciousness and ... a positive life-affirming statement that people in England are not going to passively watch their country be destroyed. They're going to put up a struggle, and they're going to put up resistance."[5] With her illustrations, books, drawings, and paintings, Coe participates in that resistance, and urges the viewer to act as well in helping to bring about positive social change. DC

NOTES

1. Sylvia Falcon, "Here Are the Facts: Interview with Sue Coe," *East Village Eye* 5 (October 1984), pp. 16–17.

2. Sue Coe and Holly Metz, *How to Commit Suicide in South Africa* (New York: Raw Books and Graphics, 1983; second printing, London: Knockabout, 1983).

3. Sue Coe and Judith Moore, *X* (New York: Raw Books and Graphics, 1986).

4. Donald Kuspit, "Sue Coe," in *Police State* (Richmond, Va.: Anderson Gallery, Virginia Commonwealth University, 1987), n.p.

5. Falcon, "Here Are the Facts," p. 16.

FOR

FURTHER

READING

Gill, Susan. "Sue Coe's Inferno." *Art News* 86 (October 1987), pp. 110–15.

LEON GOLUB

Leon Golub was born in Chicago in 1922. He received a B.A. in art history from the University of Chicago in 1942. After service in World War II, he attended the School of the Art Institute of Chicago from 1946 to 1950, earning a B.F.A. and an M.F.A. Since 1966 he has lived and worked in New York.

Leon Golub was politically active years before he began to make explicitly political art. Throughout the 1960s he protested against U.S. involvement in the Vietnam War, participating in such art-world antiwar activities as the "Artists and Writers Protest." Until the 1970s, however, his figurative paintings depicted generalized images of existential struggle, whether internalized and psychological, as in *Damaged Man* (1955), or actual and physical, as in the monumental *Combat* and *Gigantomachy* canvases of the 1960s. Golub's portrayals were not topical but timeless, a metaphoric expression of "man alone, struggling against ... social stresses."[1]

In 1972, as the hostilities in Vietnam continued to escalate, Golub resolved to replace metaphor with reportage. Over the next three years he painted three enormous pictures of Vietnam, striving for absolute objectivity by drawing his images of men, uniforms, and weapons from news photos and military handbooks. In the first two canvases, he pictured American soldiers firing on Vietnamese civilians. In the third, he depicted the soldiers at rest, their victims lying at their feet. With these gigantic protest paintings—the largest of them a full 40 feet wide—Golub established himself as one of the most ambitious and uncompromising politically engaged artists of our time.

In the years since the Vietnam War, Golub has continued to work from news photos and other media sources, and has persisted in portraying male aggressors in combat dress, armed with contemporary weapons. They are no longer identified as members of a regular army, however, but as mercenaries—hired irregulars who enforce the will of repressive governments, exercising an authority sanctioned not by law but by brute power.

Mercenaries I (1976), the earliest of the surviving *Mercenary* paintings, depicts two machine-gun-toting irregulars, one white and one black, who dangle between them a helpless, bound victim. The victim is faceless and dehumanized—we cannot even be certain if it is a man or a woman—and the location of this atrocity is unspecified. Nevertheless, the image projects an acute psychological precision.

Frequently Golub shows the mercenaries not in action but in their off-hours, at play or at rest. Yet their rest is restless: they hang onto their guns, and their interactions are shot through with tension and ambiguity. The uneasy

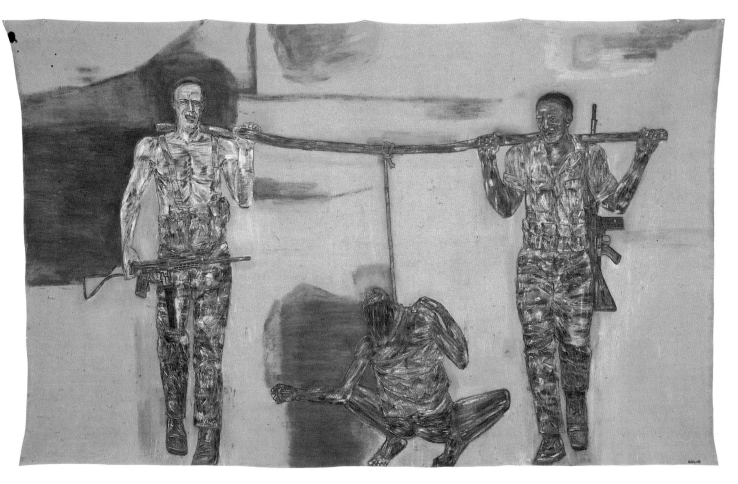

MERCENARIES I 1976
acrylic on canvas
116 × 186 ¹/₂

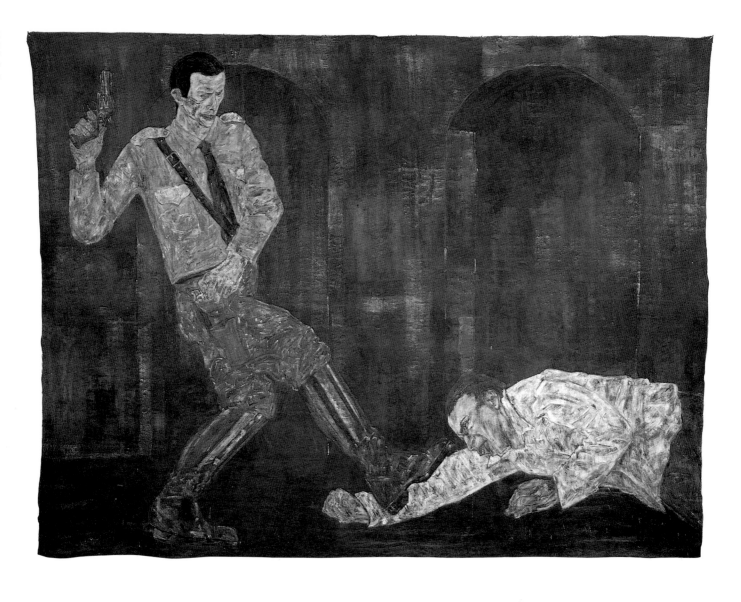

WHITE SQUAD V 1984
acrylic on canvas
120 × 161

exchange of glances between the seated soldiers in *Mercenaries III* (1980, p. 2) is fraught with uncertainty. As Corinne Robins writes, ''We don't know what their eye contact means, what kind of complicity these two killers at rest share, or whether, in fact, one of the glances may be a sexual invitation.''[2] What is certain is that these men are very close to us, psychologically and physically. Golub presents the figures at a scale twice that of life size, painted against a flat red-oxide background that pushes them forward. The giant, unstretched canvas hangs low on the wall, impinging on our environment; the figures are cut off at the knees so that we imagine their feet occupying our own space.

In the *Interrogation* and *White Squad* paintings, Golub renders acts of extreme violence, torture, and execution perpetrated by a variety of mercenaries, secret police, and death-squad goons. In *White Squad V* (1984) a pistol-brandishing officer is about to deliver a jack-booted kick to the face of a man who lies gasping on the floor. The prisonlike background with its faintly delineated arches is similar to the setting of Jacques-Louis David's *Death of Socrates* (1787). But the death that is about to occur in this prison is, unlike that of Socrates, not heroic but pathetic.

Golub insists that he is a realist reporting on situations that happen daily, even if the particular manifestations he presents have been fabricated from disparate photographs. But Golub's style is hardly photographic. He renders his figures in a harsh, acrid, illustrational mode, laying on the paint thickly, then dissolving it and scraping it down with a meat cleaver. The eroded colors and surfaces of Golub's paintings are raw, dry, and irritated, setting us on edge, increasing our discomfort. But we keep looking at them because we know that Golub is telling us the truth: this is how power operates in the modern world. And we are left uneasy in the knowledge that our own political and corporate leaders provide economic and military assistance to repressive regimes; our investments and tax dollars support the crimes to which Golub's canvases bear witness. Confronted with these images of violence, unable to intervene, we are not permitted to look away; we are implicated.　DC

NOTES
1. Leon Golub quoted in Gerald Marzorati, "Leon Golub's Mean Streets," *Art News* 85 (February 1985), p. 85.
2. Corinne Robins, "Leon Golub: In The Realm of Power," *Arts Magazine* 55 (May 1981), p. 172.

FOR FURTHER READING
Baigell, Matthew. " 'The Mercenaries': An Interview with Leon Golub." *Arts Magazine* 55 (May 1981), pp. 167–69.
Marzorati, Gerald. *A Painter of Darkness: Leon Golub and Our Times.* New York: Viking Penguin, 1990.
New Museum of Contemporary Art. *Golub.* New York, 1984.

HANS HAACKE

Hans Haacke was born in Cologne in 1936. He attended the
State Academy of Fine Art in Kassel, Germany, from 1956 to
1960, receiving his M.F.A. in 1960. In 1960–61 he studied
at Atelier 17 in Paris, and in 1961–62 at the Tyler School of
Art, Philadelphia. He has lived in New York since 1967.

One of the most resilient artists to emerge from the New Left movement
of the 1960s, Hans Haacke has maintained throughout his career an opposi-
tional position vis-à-vis the art establishment. He seeks to reveal the normally
hidden connections between art and corporate and political power, but art in-
stitutions made uneasy by this information have frequently censored his work.

The first and most notorious instance of censorship occurred in 1971,
when the Guggenheim Museum canceled an exhibition of Haacke's work
because it included photographs of various Manhattan real estate holdings,
both commercial properties and tenement buildings. The photographs were
accompanied by texts documenting the acquisition, value, and ownership of
the buildings along with business and financial data about the landlords.
Even though the information gathered by Haacke was in the public record, the
museum considered it too politically sensitive.

As the decade progressed, Haacke's presentations became more sophis-
ticated. He adopted the glossy style of corporate advertising and annual
reports to lay bare the ulterior motives behind corporate sponsorship of art
exhibitions. Haacke's works reveal that such corporate sponsorship is
designed to create an impression of enlightened public responsibility that
masks questionable corporate practices like the exploitation of third-world
resources and the support of repressive pro-Western regimes, including the
white government of South Africa. Among Haacke's frequent targets have
been Mobil, which financially assisted the South African police and military,
and the British advertising firm of Saatchi and Saatchi, a prominent supporter
of conservative British Prime Minister Margaret Thatcher, whose policies
benefited the South African regime.

In *Oelgemaelde, Hommage à Marcel Broodthaers* (*Oil Painting*, *Homage to
Marcel Broodthaers*) (1982–83), Haacke criticizes another world leader, Ronald
Reagan. This work pits an oil portrait of Reagan on one wall of the gallery
against a wall-size photographic image of an antinuclear demonstration on
the other. It was initially shown at the exhibition *Documenta 7* in Kassel, one
week after Reagan delivered an address to the West German Bundestag,
seeking support for stationing American nuclear missiles in Germany. Rea-
gan's visit was met by the largest antinuclear rally ever held in Germany,
which was recorded by the photograph in the Kassel installation. When the

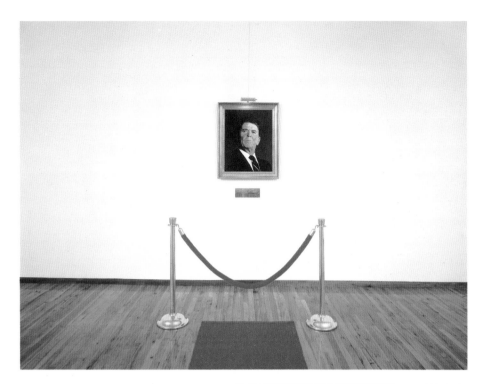

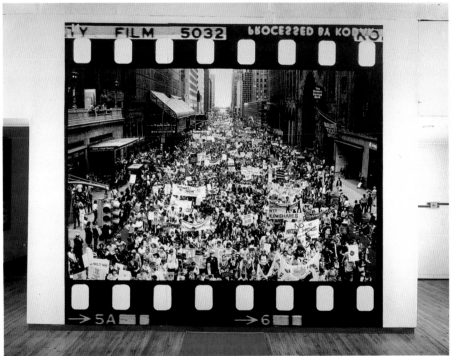

OELGEMAELDE, HOMMAGE A (*Oil Painting, Homage to Marcel Broodthaers*)
MARCEL BROODTHAERS 1982–83
(details) installation; oil painting in gold frame, picture lamp, brass plaque, brass stanchions with red velvet rope, and red carpet leading to photo mural on facing wall
overall dimensions determined by exhibition space

piece was first shown in New York in 1983, a photograph of an antinuclear march held in New York two days after the protest in Bonn was used.

Haacke's employment of a stylistically retrograde, hand-painted portrait of the ultraconservative Reagan serves a dual function. It comments on the political implications of the return to figurative painting in the 1980s celebrated at *Documenta 7*, and in the installation it serves to separate and distinguish the image of Reagan from that of the antinuclear protesters. The painting of Reagan is framed in gold, illuminated by a picture light, and distinguished by a brass label. In front of the painting hangs a red velvet rope, and rolled out on the floor before it is a red carpet. The painting is thus presented to the public as a precious, untouchable object to be admired, and the president's image is granted a sanctified aura. Head thrown back and chin in the air, Reagan appears haughty and aristocratic, his expression disdainful and imperious.

Haacke dedicates the work to the late Belgian Conceptual artist Marcel Broodthaers, who, in the catalogue preface to his *Musée d'art moderne, Département des aigles, Section des figures* (1972), drew a parallel between the mythic power of the eagle as an imperial symbol and the mythic power of art. Broodthaers noted that eagles, contrary to popular belief, are not courageous birds; they are believed to be because they project an image of power. The authority of works of art and political leaders is equally a product of projection. In Haacke's terms, "They need the red carpet, the gold frame, the aura of the office/museum—the paraphernalia of a seeming immortality and divine origin."[1]

Against the constructed image of the aloof Reagan is placed the uncomposed, black and white snapshot of marchers in the street, enlarged from a contact sheet, complete with marginal sprockets and negative numbers. As a record of a mass democratic action, its function is not aesthetic but documentary. Across from the photograph, Reagan's eyes are averted, perhaps in anger, from the protesters who would confront him. The supposedly neutral space of the gallery is revealed as a site for the workings of ideology. And we as viewers, standing on the red carpet, are invited to choose a side. DC

NOTES

1. Yve-Alain Bois, Douglas Crimp, and Rosalind Krauss, "A Conversation with Hans Haacke," *October* 30 (Fall 1984), p. 24.

FOR

FURTHER

READING

Buchloh, Benjamin H. D. "Hans Haacke: Memory and Instrumental Reason." *Art in America* 76 (February 1988), pp. 96–109, 157–59. New Museum of Contemporary Art. *Hans Haacke: Unfinished Business*. New York and Cambridge, 1986.

KEITH HARING

Keith Haring was born in 1958 in Kutztown, Pennsylvania.
He studied at the School of Visual Arts in New York from
1978 to 1979 and in the early 1980s was one of the
founders of New York's East Village art scene. In February
1990 Haring died of complications from AIDS.

Like many young contemporary artists, Keith Haring sought to alter the
experience of art by challenging the primacy of the museum and gallery
system. As did Jenny Holzer, John Ahearn, and graffiti artists such as SAMO
(Jean-Michel Basquiat), in the late 1970s Haring took his art to the streets of
New York, where it was accessible to a general audience. Using white chalk,
he drew on the black paper that covered vacant advertising boards in the
subway, often making thirty drawings in three hours. Before long, hundreds of
New Yorkers recognized his distinctive outline characters, and two in particu-
lar, the Radiant Child and the Barking Dog, became instant emblems of popu-
lar culture. The subway drawings appealed to people because they combined
a childlike exuberance with an adult concern for the future in a computerized
nuclear age.

Haring's early anonymity was replaced by rapid fame when, at the age of
twenty-two, he began showing paintings and drawings in galleries and
museums internationally. Although Haring continued to draw in the subways,
he found that with success came the power and responsibility to distribute
through his art information on social and political issues ranging from AIDS
and racism to the threat of nuclear war and the loss of individuality due to
omnipresent technology.

Untitled (1983) is a strange last-judgment scene in which the potential for
nuclear disaster impinges upon the joyful spirit of heavenly music and dance.
Although the painting might be a personal reflection on Haring's youthful
involvement in religion, it offers a more general social meaning as well. The
work is dominated by three gargantuan figures. On the left is a socket-headed
technological giant. A screen on his torso, into which small figures throw
themselves, reveals an image of a rising mushroom cloud. In the center of the
painting, several figures climb the elongated neck of a jubilant dancing giant
who is surrounded by floating angels. The third colossus, on the right, is
posed as the judging Christ, right arm raised to welcome those who have
been spared, and left arm lowered in condemnation of the damned. The refer-
ence to Christ is reinforced by another figure whose hand-shaped head is
marked with the stigmata. Yet by placing nuclear destruction with music and
dance on Christ's right side, in the space traditionally reserved for heaven,

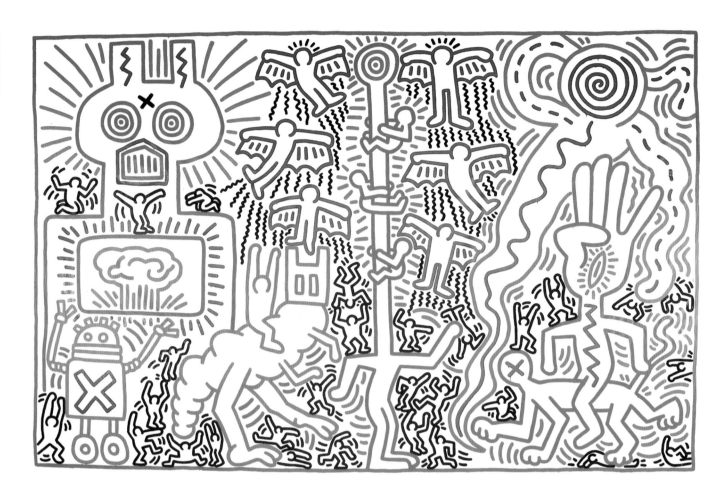

UNTITLED 1983
vinyl paint on vinyl tarp
180 × 276

UNTITLED 1984
acrylic on canvas
120 × 180

Haring seems to disallow the possibility of separating heaven and hell. Indeed, if we consider the irony of political justification for the arms race — to protect the pursuit of American happiness by building weapons that promise total destruction — we might conclude that Haring is right.

Untitled (1984) identifies another sociological problem of the late twentieth century: the dominance of technology. In this painting a huge, pink piglike monster vomits green detritus. In the refuse are computers, radios, telephones, cars, movie cameras, televisions, and guns. Men swim out of the sea of debris and seek nourishment at the nipples of the creature's thirteen breasts, an indication that nature sustains while technology becomes waste.

Haring painted quickly, without sketches or plans. Like Andy Warhol, he believed images gain meaning from repetition and recombination, and in the small pen and ink works that he did after he stopped drawing in the subway, he continually rearranged his repertoire of characters and symbols.

Haring opened his first Pop Shop in New York in 1987 and began marketing buttons, T-shirts, watches, and radios adorned with his familiar figures; through these products Haring continued to reach wide audiences. He enjoyed the irony of collectors paying large sums for art that was available in commercial form.[1] Haring also allowed characters such as the Radiant Child to be used for various social and political purposes, including the United Nations Children's Fund and antinuclear campaigns. By carefully controlling the dissemination of his images, he ensured that they did not lose all meaning. Time will tell whether Haring's symbols will continue to be relevant and how their meanings will change. His great contribution was that he expanded the accessibility of art. That he did so in a socially responsible manner is to his lasting credit.

MM

NOTES

1. Keith Haring, *Keith Haring: Artist at Work*, produced and directed by David Howard, distributed by Visual Studies, San Francisco, 1985, video.

FOR FURTHER READING

Haring, Keith. *Keith Haring, Peintures, Sculptures et Dessins*. Bordeaux: CAPC, Musée d'art contemporain, 1985.
Stedelijk Museum, Amsterdam. *Keith Haring*. Amsterdam, 1986.

JENNY HOLZER

Jenny Holzer was born in 1950 in Gallipolis, Ohio. She received an M.F.A. from the Rhode Island School of Design in 1977. In 1990 Holzer became the first woman to represent the United States at the Venice Biennale. She lives and works in upstate New York.

In the mid-1970s Jenny Holzer associated with a group of artists, which included John Ahearn, who made a new kind of public art. Distributed in and on the streets and subways of New York, their uncommissioned and often anonymous art addressed the social and political climate of the decade. Unlike the others, Holzer used language as her primary vehicle of expression.

Her first series, the *Truisms*, consisted of one-line aphorisms based on classical philosophical texts that she read as a participant in the Whitney Museum's Independent Study Program. Holzer chose the format of the anonymous underground political poster for the *Truisms*, pasting them up on buildings, walls, and signboards in New York, where their function as art was disguised.[1] Because the texts presented differing political points of view, they were not a manifesto. In fact, the title *Truisms* is an ironic commentary on the relativity of truth. To maintain anonymity and a sense of official language and objectivity, Holzer arranged the texts in neutral alphabetical order, but within a short time people had scratched out those they did not like and added others.

A constant theme in Holzer's work since the *Truisms* has been the use of public forms of expression to elicit personal response. She has continued to experiment with means of display, placing similar messages on giant electronic billboards intended for large crowds and on small, intimate benches designed for only a few individuals at one time. Ironically, as her work received greater public attention, her texts became more personal. Holzer aligned their tone more closely with her own voice, which is that of a woman, a feminist, and a mother critical of the way authority is manifested in our age. Over the past decade the words have also grown increasingly confrontational. Their visual impact and subject matter—war, violence, racism, rape, sex, disease, birth, and death—are not easy to forget.

In *Under a Rock* (1986), Holzer's first full installation, she brings the implicit tension between private and public meaning into explicit conflict. The atmosphere of the installation is evocative of a chapel: silent, meditative, and dark. On the walls three LED (light-emitting diode) signs flash brightly colored messages. In front of them are ten black granite benches on which short texts are inscribed. Typically, the words on public LED boards display

UNDER A ROCK 1986

(detail) installation of thirteen works; three electronic LED signs
and ten granite benches

the weather, sports updates, and short news bulletins. Holzer borrows this format but considerably alters its content. In *Under a Rock*, short paragraphs evoke images of rape, violence, racism, AIDS, and death. Although written in the banal, falsely objective tone of news reporting, they are accusatory: "Crack the pelvis so she lies right. This is a mistake. When she dies you cannot repeat the act. The bones will not grow together again and the personality will not come back. She is going to sink deep into the moss to get white and lighter. She is unresponsive to begging and self-absorbed." "Nothing will stop you the mad foreigner. No one sees you walking with a tick tick in your dick. You set a bomb in the queen city of the big nation to start the war that stops when silence breaks the ears of dead people." The bright colors and dizzying effect of the speeding text mitigate the reader's horror on realizing that he or she is the one accused. The benches are a visually soothing respite from the stimulation of the LED signs, but seated there we have time to linger over our reading, and the impact of the accusation becomes more powerful. These phrases force us to confront ourselves, our actions, and our beliefs.

A chapel seems an unlikely place for an electronic LED display, yet color, light, and art have been part of churches for centuries. By placing an LED sign in a chapel-like context and by altering its content, Holzer subverts its familiar strategy of representation. The artist has referred to *Under a Rock* as her "chapel of doom."[2] Indeed, the texts themselves suggest little hope for salvation, but by forcing us to face ourselves, Holzer increases the possibility of change.

MM

NOTES

1. Jenny Holzer, lecture at Mills College, Oakland, Cal., May 3, 1989.
2. Michael Auping, *Jenny Holzer: The Venice Installation* (Buffalo, N.Y.: Albright-Knox Art Gallery, 1990), p. 30.

FOR

FURTHER

READING

Solomon R. Guggenheim Foundation. *Jenny Holzer*. New York: Harry N. Abrams, 1989.

ANSELM KIEFER

Anselm Kiefer was born in Donaueschingen, Germany, in March 1945. He studied art informally under Joseph Beuys at the Düsseldorf Academy in the early 1970s. Since 1971 he has lived and worked in Hornbach in the Odenwald Forest, near Buchen, Germany.

Of the younger German painters to emerge in the past decade, the one who has made the greatest impression on international audiences, and on Americans in particular, is Anselm Kiefer. Kiefer's impact on this side of the Atlantic is explained in part by the sheer physical power of his paintings. Many of them are immense, covering entire walls, their surfaces clotted with not only paint but also straw, sand, bits of metal, molten lead, gold leaf, copper wire, ceramic shards, photographs, and scraps of paper. The magnitude and material density of Kiefer's surfaces have led more than one critic to identify him as the aesthetic heir of Jackson Pollock.

What distinguishes Kiefer, however, from Pollock and from his German contemporaries is his persistent exploration of subject matter from German cultural and political history. Born during the closing months of World War II, Kiefer had no firsthand experience of the rise and fall of the Nazis, and he grew up in a postwar society that actively repressed memories of the Third Reich and the Holocaust. But Kiefer, like a "latter-day Prince Hamlet," felt the need to examine the meaning of his "bitter patrimony."[1] And so he has invoked in his art grandiose Nordic, Neoclassical, and Wagnerian themes, resurrecting a world of German romantic imagery that had been tainted seemingly beyond redemption by the Nazis' political use of it.

Many of Kiefer's countrymen are discomfited by his probing of the problematic German past. His intention is to remind the German people of their own terrible history and to force them to deal with its implications.[2] But German critics have accused Kiefer of secretly identifying with the Nazis, and have warned that his revival of Nazi-inflected imagery could be used by others to reinforce resurgent German fascism. In contrast, in the United States as well as in England and Israel, Kiefer's journey into the German past has been seen as a courageous effort at atonement for the sins of his ancestors—not through forgetfulness but through catharsis.

An understanding of Kiefer's paintings as expiatory explains their elegiac cast. These are not paintings that trumpet a freshly revived German nationalism; rather, they roam the dark and ancient forests, fields, and chambers haunted by the ghosts of that national spirit. One such place is the cavernous wooden hall of *Deutschlands Geisteshelden* (*Germany's Spiritual*

DEUTSCHLANDS GEISTESHELDEN (*Germany's Spiritual Heroes*)
1973
oil and charcoal on burlap mounted on canvas
121 × 268 ½

Heroes) (1973). In each bay of this timeless Valhalla (an interior actually based on a schoolhouse attic that Kiefer used as a studio), a spectral torch burns, beneath which is written the name of one of the titular spiritual heroes. The first named at the lower left is Richard Wagner (1813–83), followed by Joseph Beuys (1921–86), Caspar David Friedrich (1774–1840), Frederick the Great (1712–86), Austrian novelist Robert von Musil (1880–1942), and German painter Hans Thoma (1839–1924). On the right side are the German poet Richard Dehmel (1863–1920), Austrian poet Josef Weinheber (1892–1945), Austrian novelist Adalbert Stifter (1805–68), Swiss painter Arnold Böcklin (1827–1901), German mystic Mechthild von Magdeburg (c. 1212–c. 1280), Austrian poet Nikolaus Lenau (1802–50), and German poet Theodor Storm (1817–88).[3]

Kiefer invokes this pantheon in *Germany's Spiritual Heroes* with a mixture of reverence and irony. The appearance of the name of Joseph Beuys, Kiefer's mentor, indicates the artist's sincere admiration for the works of the men he memorializes. But, as Mark Rosenthal has noted, the work's title, taken from an elementary-school text, is so pedantic it is ultimately comical, and the memorial flames threaten to burn down this highly flammable wooden room, destroying with it Germany and its heroes.[4] Kiefer thus reveals the instability of the country's past as well as the uncertainty of its future. His own position seems to coincide with that of the transparent, apparitional figure that hovers in the distance of the great memorial hall, to the right of the far doorway. The figure could be the artist's spiritual self-portrait, standing to one side of the great perspectival sweep of the space—standing, as it were, inside the chamber of history but refusing to be caught up in its flow. This is the ambiguous posture that Kiefer takes as a contemporary German artist exploring the troubled, shrouded past of his culture. What gives his art such power is his commitment to deal passionately with all the difficulties that this position is heir to. DC

NOTES

1. James Yood, "The Specter of Armageddon," *New Art Examiner* 15 (April 1988), p. 26.

2. Kiefer is paraphrased to this effect by Steven Henry Madoff, "Anselm Kiefer: A Call to Memory," *Art News* 86 (October 1987), p. 128.

3. The identifications are made by Mark Rosenthal in *Anselm Kiefer* (Chicago: Art Institute of Chicago; Philadelphia: Philadelphia Museum of Art, 1987), p. 156, n. 36.

4. Rosenthal, *Anselm Kiefer*, pp. 26, 30.

FOR

FURTHER

READING

Schjeldahl, Peter. "Our Kiefer." *Art in America* 76 (March 1988), pp. 116–27.

BARBARA KRUGER

Barbara Kruger was born in Newark, New Jersey, in 1945. She studied at Syracuse University and Parsons School of Design. She has worked as a graphic designer and has curated exhibitions and organized lectures. In addition to making art, she writes essays and film and television criticism. She lives and works in New York.

Untitled (*Your Body Is a Battleground*) was designed by Barbara Kruger as a poster for the massive pro-choice march that took place on April 9, 1989, in Washington, D.C. In addition to the above words printed over a photographic image of a woman's face, the poster included text identifying the time and location of the march, its historical significance, and the specific political message "Support Legal Abortion, Birth Control, and Women's Rights." The work was neither commissioned nor endorsed by the march organizers; Kruger and her students at the Whitney Museum's Independent Study Program volunteered hours of their time to cover walls in lower Manhattan with the posters. Like many of Kruger's compositions, this one was quickly adopted by the mass media. Kruger allowed the image to be reproduced on postcards with the text "Support Legal Abortion, Birth Control, and Women's Rights"; she permitted it to be altered for the cover of a recent book on gender, politics, and the avant-garde;[1] and she made a unique work from it, which is seen here. As a work of art the image has a more general meaning than the poster, although it is still politically charged.

Kruger typically borrows from various mass media, and applying her earlier training in graphic design, she alters the appropriated images to make them more visually arresting. The woman in *Untitled* (*Your Body Is a Battleground*) recalls stylized fashions of the 1950s, and is particularly reminiscent of makeup and perfume advertisements. Such ads worked to culturally inscribe specific notions of women as consumers of products designed to make them appealing to men, and ultimately as objects of male consumption. Kruger has enlarged the woman's face to gigantic proportions, cropping it at the forehead and just below the chin, and she has separated the face symmetrically along its vertical axis into a photographic positive and its corresponding negative. These manipulations emphasize the political content of the work, which undermines the cultural roles that men and women are traditionally assigned. Against a stereotype of the 1950s woman, an attractive, placid, and acquiescent Donna Reed type, Kruger juxtaposes her opposite, a forceful, self-assured, disembodied Big Brother in the guise of Big Sister, who watches over gallery visitors. Her demure expression is negated by the

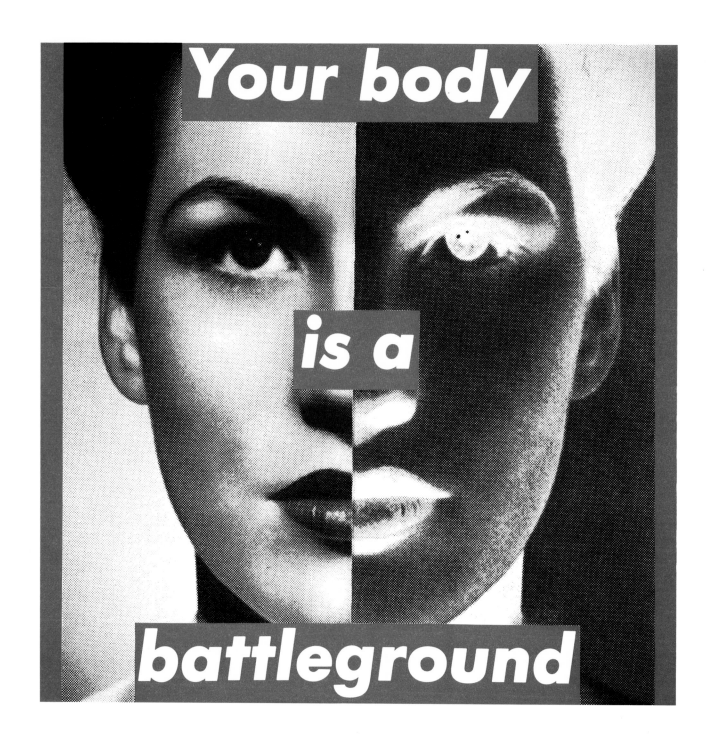

UNTITLED 1989
(YOUR BODY IS A BATTLEGROUND) photographic silkscreen on vinyl
112 × 112

ROY TOY 1986
color photograph
138 1/2 × 90 1/2

stridency of the words she delivers. The phrase is a slogan from the 1960s that Kruger renews and revitalizes by placing it in a new context. Today the struggle for women's freedom occurs as much in media representations as it does in political action. The body is still the battleground, but body and battleground are increasingly defined by the media. Yet Kruger, who is a product of the electronic-communication age, believes it is only by mastering media portrayals that new paradigms of identity will be invented.[2] In her words, it is only by acting within the "site of the stereotype ... that the rules of the game can be changed and subtle reformations can be enacted."[3]

In *Roy Toy* (1986), Kruger is less concerned with an explicitly feminist cultural critique. Based on appropriated media sources, the work features a wildcat, prey in mouth, and a small photograph of McCarthyite Roy Cohn.[4] The text refers to the film character Dirty Harry, a police officer who goads villains to provoke him to fire with the now-familiar cliché "Go ahead, make my day." Using well-known media codes of language and image (Roy Cohn was often seen during the televised McCarthy hearings), Kruger complicates the issues of political oppression and the triumph of good over evil by comparing them with instinctual behavior in animals. MM

NOTES

1. Susan Suleiman, *Subversive Intent: Gender, Politics and the Avant-Garde* (Cambridge, Mass.: Harvard University Press, 1990).

2. Barbara Kruger and Kate Linker, *Love for Sale* (New York: Harry N. Abrams, 1990).

3. Jeanne Siegel, "Barbara Kruger: Pictures and Words," *Arts Magazine* 61, no. 10 (Summer 1987), p. 20.

4. Howard Fox, *Avant-Garde in the Eighties* (Los Angeles: Los Angeles County Museum of Art, 1987), p. 66.

ROBERT LONGO

Robert Longo was born in 1953 in Brooklyn, New York. He received a B.F.A. from the State University of New York, Buffalo, in 1975. He has directed films and videos and collaborated on multi-media performances. He lives and works in New York.

Robert Longo's drawings and reliefs are suspended between tradition and a heightened awareness of the present. This conflict is acted out in the production of his works, in their subject matter, and in their style. The result is paradox and ambiguity where we expect resolution and clarity, and the constant deferral of meaning rather than the fulfillment of desire.

Robert Longo burst upon the art world in January 1981 when he exhibited a series of drawings called *Men in the Cities* at Metro Pictures gallery in New York. By March of that year he was on the cover of *Arts Magazine*. The exhibition consisted of six 9-by-5-foot black and white drawings of men in contorted poses, frozen in a moment of either forceful play (slam dancing) or violent death. The figures float unanchored against the background of the white paper, which suggests both extreme flatness and infinite depth. *Men in the Cities* dominated Longo's work for three years, from 1979 to 1982. During that time he incorporated women and groups of figures into the series. Although the arrangement of individual figures changed, the basic choreography remained the same. Almost immediately the figures in *Men in the Cities* became archetypes of a late 1970s or early 1980s urban antihero.

Although the works can be seen as part of the long history of figure drawing, they push the genre to new extremes. Their scale is more like that of film than of traditional drawing. That Longo was assisted by a professional illustrator further complicates the relationship of the series to traditional drawing.

The earliest works in the *Men in the Cities* series were based on a still from the 1970 Rainer Fassbinder film *The American Soldier*, which ends with a gangster being shot in the back. In a 1977 sculpture of the same title, Longo depicted the contorted pose of the gangster clutching his wound while lurching forward. In the drawings Longo further animated the figure, exaggerating his movements so that the sense of falling—of reeling and writhing—is accentuated. The effect is ironic: a film still into which motion has been restored.

The early works in the series also derived from fashion advertisements that Longo clipped from magazines. Longo adopted the styles of the 1950s: the men wear black slacks, white dress-shirts, and thin ties, while the women appear in skirts and blouses or dresses. Because the "uniform" is a cliché, it expresses anonymity and could represent almost any professional. Yet the

UNTITLED *(White Riot Series)*
1982
charcoal, graphite, and ink on paper
96 × 120

models for the drawings are identifiable individuals from among Longo's friends whom he posed and photographed. He then projected the pictures onto large sheets of paper and drew the figures, omitting details of personality and place and often replacing the body parts of one model with those of another. Working through the intermediary media of photography and advertising and the cinematic practices of photographic manipulation and editing gives Longo great control over his chaotic images. Such tension between order and disorder in the drawings partly reflects the increasing lack of control we have over our destiny in the late twentieth century (consider the impact of AIDS, terrorism, the threat of nuclear war, and increasing corporate ownership) and the resulting need to reassert authority over our lives.

Men in the Cities led in 1982 to the mixed-media work *National Trust* and the *White Riot* series, a second group of drawings related in image and execution to the earlier series. In *Untitled (White Riot Series)*, a cluster of men and women wrestle with each other against an empty backdrop. The uniform has given way to a few departures — a black tank-top, a plaid shirt — and the gestures are more violent. Figures grab each other with strength enough to impress the flesh. Hands are locked in combat; men and women are equally engaged. The effect is less of bodies in motion than of limbs in chaos. Hope, manifested before in the possibility of play, is replaced by a more pessimistic vision. The struggle for power against the anonymous forces in the earlier series becomes a display of human aggression, a struggle for power among individuals.

Since 1982, Longo has adopted a strategy of representation based on the appropriation and odd juxtaposition of media sources. While drawing remains central to these works, it has been incorporated into large-scale multi-media reliefs. Longo continues to be concerned with the relationship of the individual to structures of power in contemporary culture, including mass media such as film, television, and video. Increasingly the existence of the individuals in these works is threatened by the weight of the monuments and landscapes surrounding them. MM

FOR

FURTHER

READING

Prince, Richard. *Men in the Cities*. New York: Harry N. Abrams, 1986.
Longo, Robert. *Robert Longo*. Los Angeles: Los Angeles County Museum of Art; New York: Rizzoli, 1989.

ROBERT MORRIS

Robert Morris was born in Kansas City, Missouri, in 1931.
Following a brief enrollment at the University of Kansas City
as an engineering student, he studied art at the Kansas City
Art Institute from 1948 to 1950 and at the California School
of Fine Arts, San Francisco, in 1951. After serving in the
Army Corps of Engineers in 1951–52, he finished his
undergraduate education at Reed College in Portland,
Oregon, from 1953 to 1955. In 1962 he received an M.A. in
art history from Hunter College, New York, and has worked
and exhibited in New York since that time.

For the past decade, Robert Morris's art has dealt with the horrors of nuclear war and mass annihilation. His disturbing explorations, explicitly representational, have come as a surprise to those familiar only with his Minimalist abstractions of the 1960s. Morris in fact devoted only a few years, 1964 to 1968, to the production of literal, geometric forms in the shape of boxes, slabs, and L-beams. Before these works, in the early 1960s, he made ironic Duchampian objects, and during and after his Minimalist phase, he also did performance art and scatter installations, made Antiform felt sculptures, and constructed labyrinths and earthworks.

Although Morris began to treat overtly the subject of mortality only in the 1980s, his entire career can be seen, conceptually and thematically, as a meditation on the inevitability of death. Morris's art, as Donald Kuspit notes, has always been intensely physical: "Death's concreteness was his art's implicit subject matter from the start."[1] Morris's sculptures and earthworks of the 1960s and 1970s often evoked coffins, tombs, and burial mounds. Passage through a labyrinth, one of Morris's favorite symbols, is understood in many cultures as a mythical journey through death to the afterlife. And significantly, in 1965 Morris proposed a design for his own mausoleum.

The central image of Morris's grim and imposing *Untitled* (1987) comes from a photograph in the Yad Vashem Holocaust Memorial Archives in Jerusalem. It shows the lifeless bodies of the victims of a Nazi death camp, heaped atop one another in a bulldozed mass grave. The enlarged photograph is silkscreened onto two aluminum panels, covered with a layer of encaustic, and bracketed by four sculpted elements that project, cornicelike, from the wall. Within the geometric borders of the black fiberglass frames swarms a welter of body parts, mechanical elements, and organic debris. Cast from life, but now frozen in the stasis of death, this apocalyptic jumble—leaves, twigs,

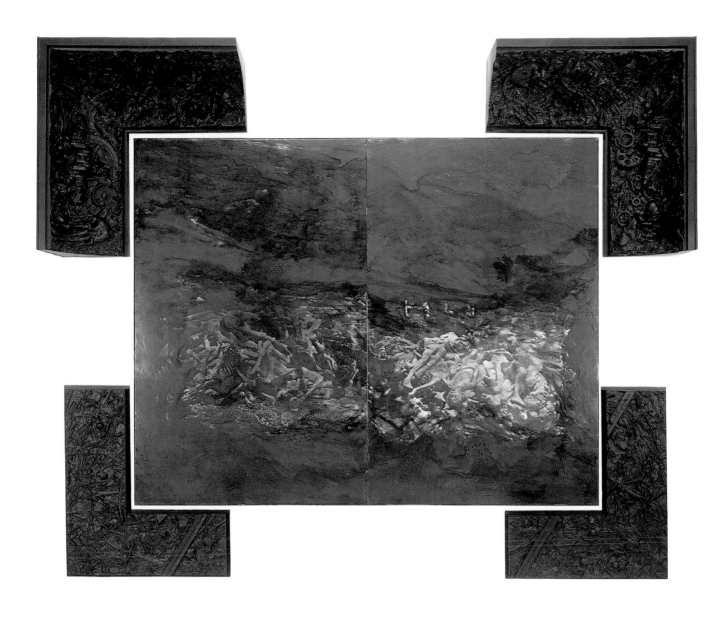

UNTITLED 1987
silkscreen, encaustic on aluminum panels,
and painted cast fiberglass
102 × 124 × 14

crankshafts, gears, skulls, hands, intestines, and phalluses—represents the fossilized remains of the Holocaust.

In the monumental tableau, the gruesome but artificial spectacle of the cast body parts is eclipsed by the primary, actual horror documented in the central photograph. Morris indicts the irrational forces of hatred and evil responsible for the unprecedented slaughter during the Holocaust, which the artist considers "the most singular event of the twentieth century."[2] Yet Morris eschews the angry, expressionistic tenor typical of protest art; behind the creation of this work seems to be a fundamentally aesthetic impulse. Veiling the central photograph behind a smoky patina of encaustic, Morris imparts to the pile of corpses an Old Masterly glow, echoing in both color and composition Gericault's *Raft of the Medusa* (1818–19; see p. 76, fig. 5). The black frames are equally redolent of art-historical associations, from the swarming figures of Rodin's *Gates of Hell* (1880–1917) to the cast-plaster body parts of Jasper Johns. In their contours, they even call to mind Morris's Minimalist L-beams of the 1960s.

Morris has been accused of seeking through this intensely aesthetic effort to neutralize or, worse, glamorize the horror of the death camps.[3] On the contrary, the work represents a tremendous act of life-affirming will. Here is an artist who struggles to transcend death not by endeavoring to avoid it but by confronting it head-on. Composing that which naturally decomposes, concretizing that which is destined to crumble, Morris counteracts the destructive forces of time and human irrationality by pitting against them his own unceasing, constructive labors. DC

NOTES

1. Donald B. Kuspit, "The *Ars Moriendi* According to Robert Morris," in *Robert Morris: Works of the Eighties* (Chicago: Museum of Contemporary Art; Newport Beach, Cal.: Newport Harbor Art Museum, 1986), p. 13.

2. Robert Morris, "Three Folds in the Fabric and Four Autobiographical Asides as Allegories (or Interruptions)," *Art in America* 77 (November 1989), p. 150.

3. Corinne Robins, "Robert Morris: Death and Picture Frames," *Arts Magazine* 62 (May 1988), pp. 74–75.

FOR FURTHER READING

Patton, Phil. "Robert Morris and the Fire Next Time." *Art News* 82 (December 1983), pp. 84–91.

Morgan, Robert C. "Robert Morris: Confronting the Facility of Denial." *Flash Art* 140 (May/June 1988), p. 122.

TOM OTTERNESS

Tom Otterness was born in 1952 in Wichita, Kansas. He studied art in New York at the Art Students League in 1970, and in the Independent Study Program of the Whitney Museum of American Art in 1973. In 1977 he was a founder of Collaborative Projects, Inc. (Colab), in New York.

In his individual works and monumental tableaux, sculptor Tom Otterness employs the childish vocabulary of cartoons and fairy tales to comment on the unequal distribution of wealth among the classes and the continuing war between the sexes. As characters, Otterness's happy homunculi, dopey frogs, top-hatted turtles, and smiling robots are whimsical and beguiling. But the narratives they enact are in turn profound and portentous. Otterness's art depends for its effectiveness on this discrepancy between blithe form and grave content.

In his first New York solo show in 1983, Otterness diplayed a seventeen-panel frieze that wrapped around the doorframe and the tops of the gallery walls like a continuous strip of architectural decoration. The masses of stubby, round-headed, smiling figures that populate these narrow reliefs seem on first view to be involved in charming, playful diversions. But closer inspection reveals that many are hard at work, hoisting heavy spherical and cylindrical loads. Others are engaged in physical combat. And in two panels, each devoted to one gender, a king is toppled by revolutionary male and female workers. Beginning with "Paradise" and culminating in the "Judgment," Otterness constructed a complete narrative cycle that the viewer could follow around the gallery walls.

Otterness thus retained the traditional ideological function of the narrative frieze by using it to deliver a public message. But insofar as his frieze did not adorn a triumphal arch, cathedral tympanum, or other such locus for the dissemination of a fixed and particular exhortation, its ultimate meaning remained open to interpretation. And this meaning was further destabilized by the artist's willingness to sell the frieze by the foot for installation in any space, public or private. With each change of context and fragmentation of the narrative (according to how many panels of the frieze were installed), the work would necessarily take on a different significance.

Such is the case with *Mass Workers* (1983), which comprises a selection of panels from Otterness's original frieze. Here fourteen of the 4-foot-long panels are stacked atop one another to form a vertical slab. In its silhouette the piece evokes a stele such as might have adorned a temple in ancient Assyria, Egypt, or India. It is equally reminiscent of the bronze doors of a

MASS WORKERS 1983

painted cast polyadam

141 × 45 × 6

Renaissance cathedral. The sculpted personages also seem rooted in antiquity, recalling Cycladic harpists, Japanese *haniwa*, and Pre-Columbian votive statues. And if they also call to mind more recent sources, including the pneumatic figures of Picasso and Léger, the laborers of American WPA art, and such media characters as the cartoon caveman Alley-Oop and the Pillsbury Doughboy, still, none of these references is absolutely contemporary. Otterness's art is imbued with an aura of nostalgia—for history and childhood—and its figures project a charming innocence lost to the present-day viewer.

But that sense of innocence is contradicted by the details, as is so often the case in Otterness's work. We notice that these humans are not generic but gendered; they have clearly articulated sexual organs. Furthermore, they are segregated into discrete panels, female and male alternating from top to bottom. Significantly, the work performed by the female and male workers is exactly the same. This is apparently a utopian society that does not distinguish between "women's" work and "real" (men's) work. Still, we cannot help wondering why the sexes are separated, and what the point of their labor is.

Then there are the two incongruous panels, identified by Otterness as "The Boating Party" (third from the top) and "The King's Parade" (third from the bottom). When it was part of the complete frieze, "The Boating Party," which depicts women pausing from their labors to enjoy nature, was followed, after a scene of exertion, by their heroic toppling of the patriarch. Similarly, as an episode in the full composition, "The King's Parade," which shows the monarch waving from his car while his motorcade rides through the ranks of the laborers, was succeeded by a male uprising that ends with the king's car overturned and his rule overthrown. The viewer of *Mass Workers*, however, has access to neither of these revolutionary scenarios. The narrative of this slab, as the title implies, remains centered in labor, in the toil of the masses— strenuous, repetitive, and apparently pointless. DC

FOR

FURTHER

READING

Kirshner, Judith Russi. "Tom Otterness' Frieze." *Artforum* 20 (October 1983), pp. 57–60.

Robinson, Walter. "Arcadian Hijinks." *Art in America* 73 (December 1985), pp. 95–97.

Brooke Alexander Gallery and James Corcoran Gallery. *Tom Otterness.* New York and Santa Monica, 1990.

CINDY SHERMAN

Cindy Sherman was born in Glen Ridge, New Jersey, in
1954. She received a B.A. from the State University of New
York, Buffalo, in 1976. From 1977 she has lived and worked
in New York.

Since the late 1970s Cindy Sherman has made and exhibited hundreds of
photographs of herself. She is not a self-portraitist, however, for in none of her
pictures do we recognize the real Sherman, but instead see an artificial one.
Adopting an endless variety of roles, poses, and guises, she continually trans-
forms her appearance by makeup, wigs, costumes, and occasional prosthetic
devices. Sherman's real subject is not herself but the ways in which the self—
the female self in particular—is constructed and represented in art and the
media of film, television, and advertising.

Sherman's earliest photographs, the *Untitled Film Still* series, explore
stereotypical depictions of women in films of the 1950s and 1960s. In each of
these photographs Sherman casts herself in an unidentified scene, with pose,
makeup, costume, props, and setting so precise as to suggest a specific
movie. Looking at *Untitled Film Still* (1978, p. 1), for example, we could almost
swear that we have seen before this raven-haired woman in sunglasses, who
stands by the sliding glass door of a cheap motel, holding a martini glass in
one hand and suggestively hitching up her dress with the other. But our
desire to learn the real movie reference or the scene's narrative context is
denied. The only thing we know for certain is that here, as in all of the imagi-
nary film stills, we are watching Cindy Sherman play a particular character.
She emphasizes the artificiality of the role and reveals our willingness to
accept this constructed role as natural.

Perhaps no part is more artificial than that played by the 1950s pinup
model, the pose adopted by the recumbent Sherman in *Untitled Film Still*
(1978, p. 63). She lies amid tousled sheets, in black bra and white panties, a
mirror in her right hand signifying her narcissism. Her facial expression, with
vacant, skyward rolling eyes and glossy, parted lips, is so utterly vapid as to
embarrass any lascivious male viewer who might approach this picture seek-
ing libidinal stimulation. Sherman mocks the dated, dehumanizing conven-
tions of 1950s glamour and makes the male viewer self-consciously aware of
the operations of his eroticized gaze.

In subsequent series of color photographs Sherman employs another
convention of glamour photography, the horizontal format of the centerfold.
Working on a large scale (2 by 4 feet), she achieves a new degree of intimacy
by photographing herself indoors and close up, her body cropped to fit into the

UNTITLED FILM STILL 1978
black and white photograph
edition 5/10
10 × 8

UNTITLED 1981
color photograph
edition 10/10
24 × 48

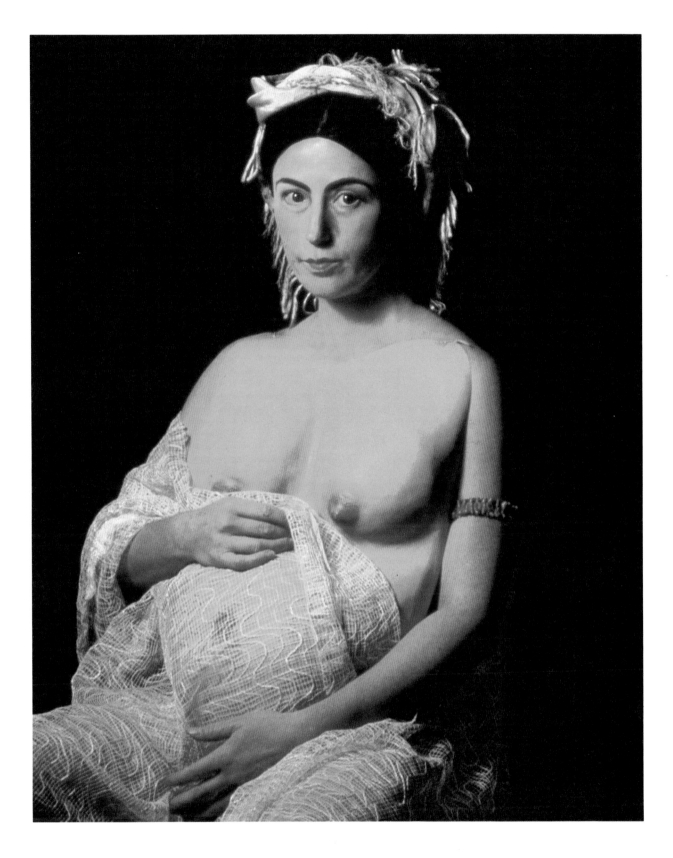

UNTITLED 1989
color photograph
edition 3/6
53 ½ × 40 ½

65

UNTITLED 1989
color photograph
edition 2/6
92 $^{7}/_{8}$ × 35 $^{7}/_{8}$

frame. In these works Sherman plays contemporary women. Typically, they lie on the floor, but for the most part they are not sexually inviting. They are fully clothed and often appear, as does the disheveled blonde in *Untitled* (1981, p. 64), to be dazed, disoriented, and victimized. Sherman says she decided to show in these images "the part of these people in the centerfolds . . . that the photographer doesn't want to take pictures of."[1]

Untitled (1982), in which Sherman appears as an ordinary contemporary woman who seems lost in a reverie, is distinguished by its use of dramatic, Caravaggesque lighting. In the mid-1980s, Sherman's photographs became larger, more colorful, more complex—in short, more like paintings. Her attention shifted from playing parts to constructing visual tableaux, and Sherman herself began to disappear from the scenes she photographed. These often gruesome, lurid, and repulsive scenes involved themes of mutilation, decay, and putrefaction. Yet they remained clearly artificial, playing on the trashy effects of low-budget horror and sci-fi flicks.[2]

Sherman's drive to achieve in photography the scale and visual impact normally associated with painting led to her most recent body of work, in which she tackles the conventions of painting itself. Once again dressing up for the camera, Sherman restages sittings from European portrait-painting of the fifteenth through the early nineteenth centuries. She simulates the idiosyncratic expressions, poses, and costumes of the subjects immortalized by such painters as Piero, Fouquet, Holbein, Caravaggio, Goya, and Ingres. In one image (*Untitled*, 1989, p. 65), Sherman poses as La Forinara, just as the model might have been painted by her lover Raphael, or later by Ingres, except that Sherman's Forinara exposes milk-swollen (plastic) breasts and cradles a (false) pregnant belly beneath her shawl. In another photograph (*Untitled*, 1989, p. 66), Sherman impersonates a late eighteenth-century bourgeois gentleman who looks rather smug and ridiculous in his wig and cravat.

In these images Sherman's real subject is the mutability and flux of fashion, cosmetics, coiffures, and comportment. Each photograph subverts the portrait's traditional function of capturing and immortalizing the appearance and personality of a unique individual. Sherman's investigations call into question the very idea of a fixed, stable, unmediated self, and suggest instead that people have always defined themselves through the masks they wear and the roles they play. DC

NOTES

1. Cindy Sherman quoted in Gerald Marzorati, "Imitation of Life," *Art News* 82 (September 1983), p. 87.

2. Lisa Phillips, "Cindy Sherman's Cindy Shermans," in *Cindy Sherman* (New York: Whitney Museum of American Art, 1987), p. 15.

FOR

FURTHER

READING

Collins, Glenn. "A Photographic Self-Portraitist Never Sees Herself in Her Art." *New York Times*, February 1, 1990, sec. B, p. 3.

ANDY WARHOL

Andy Warhol was born Andrew Warhola in 1928 in Pitts-
burgh. He received a B.F.A. in pictorial design from the
Carnegie Institute of Technology in 1949. At his death in
1987, he was among the most celebrated of American art-
ists. In 1989 a major retrospective commemorating Warhol's
long career toured the United States and Europe.

For many of the artists in this collection, Andy Warhol was a mentor and a
friend. A generation older than most of them, he set precedents in his art that
others followed. By using industrial processes such as silkscreen in his paint-
ings and by employing assistants in the production of his art, Warhol chal-
lenged the primacy of the original work of art and made a virtue of endless
repetition. He applauded such tools of mass culture as television and advertis-
ing and sought to incorporate them into his art. His portraits are based on
Polaroid photographs or mass-media reproductions, not, as convention would
dictate, on life drawing.

Perhaps Warhol's most significant legacy was his eagerness to reengage
art with history and contemporary culture through the vehicle of mass media.
Robert Rauschenberg, Jasper Johns, and various Pop artists also pursued this
goal, but Warhol's immediate grasp and incessant exploitation of the relation-
ship between art, history, politics, and mass communication set him apart.
Unlike the others, he created a style so indicative of mass media that it imme-
diately began to influence the culture upon which it was based. Today the
same effect can be attributed to Haring, Holzer, Kruger, and Longo. What
distinguishes Warhol from these younger artists is the ambiguity of his social
and political position and the extreme campiness of his approach to art and
the world. Warhol reveled in the fact that he had become his own greatest
multi-media invention, whereas artists of the younger generation seek to
subvert the power structures they find.

After his paintings of Campbell's soup cans, Warhol's best-known works
are his portraits. Celebrities, artists, art dealers, collectors, politicians, and
fictional characters appear continually in his work, which functions as a
visual *Who's Who* of the twentieth century. Warhol repeatedly painted Leo
Castelli, James Dean, Howdy Doody, Sidney Janis, Mick Jagger, Jacqueline
Kennedy, Mao Tse-tung, Mickey Mouse, Marilyn Monroe, Elvis Presley,
Robert Rauschenberg, Elizabeth Taylor, and many other subjects who rep-
resent power (journalistic, political, financial) and commercial success. The
many versions of *Mao Tse-tung* that Warhol painted between 1972 and 1974
stand out among the portraits, for Warhol portrayed fewer politicians than

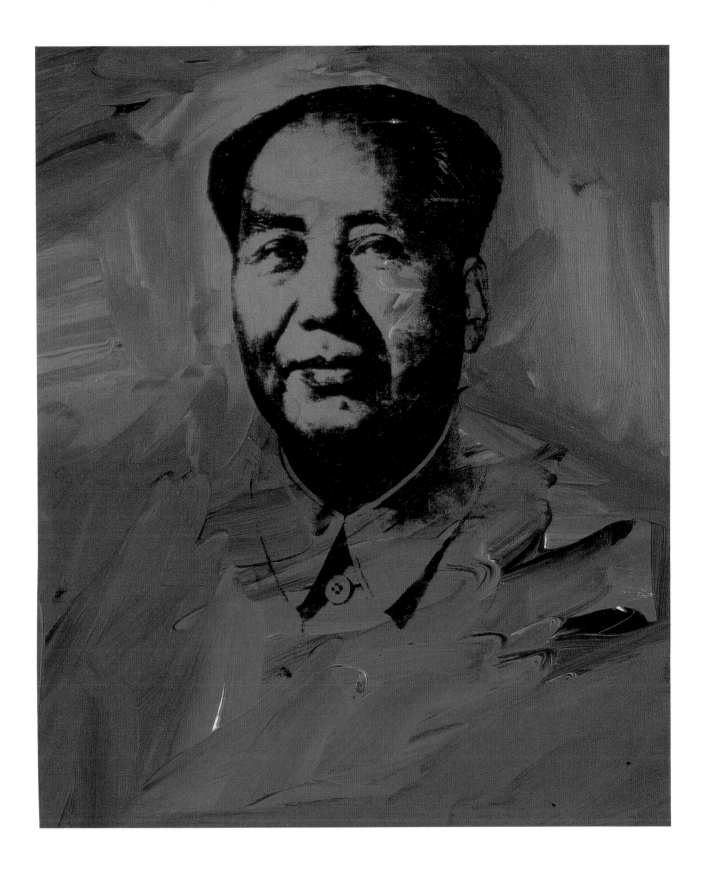

MAO-TSE-TUNG 1973

acrylic and silkscreen on canvas

26 × 22

celebrities despite the increasing alliance between media and politics.

The portraits of Mao are based on a photograph of the chairman printed as the frontispiece to *Quotations from Chairman Mao Tse-tung*. Warhol made a silkscreen from the photograph, which could be manipulated easily and transferred repeatedly to canvas. Once the likeness had been silkscreened onto the canvas, he painted over it, occasionally screening additional scribbled lines that evoke hand drawing. This technique signaled a renewed interest in painting for Warhol, who had been striving for a machinelike similarity of images.[1] Warhol's brushstrokes evoke the gestural painting of Abstract Expressionism even as the chairman's direct gaze recalls propaganda posters. Together the subject and style are ironic: oppressive totalitarian control is covered by individual expression. The abstractions of art and politics are simultaneously brought into conflict and equated.

As equivocal as Warhol's other political gestures, his images of Mao might be a critique of Chinese government and American politics or a celebration of the opening of Chinese-American relations following President Nixon's visit to China and the admission of China into the United Nations. In 1974 Warhol made *Mao Wallpaper* by silkscreening a portrait sketch onto blank wallpaper. The paper was used later as the backdrop for an installation of several Mao paintings at the Musée Galliera in Paris. With this gesture he transformed the once fearsome Chinese leader into a symbol of commercial American kitsch. MM

NOTES

1. Marco Livingstone, "Do It Yourself: Notes on Warhol's Technique," in *Andy Warhol A Retrospective*, ed. Kynaston McShine (New York: Museum of Modern Art, 1989), p. 74.

DAVID WOJNAROWICZ

David Wojnarowicz was born in Redbank, New Jersey, in
1954. He is a visual and performance artist and makes
videos and films. He lives and works in New York.

Like a number of other artists in this catalogue, David Wojnarowicz
initially made art in the streets of lower Manhattan. Unlike them, however, he
did not co-opt media stereotypes or borrow media strategies in order to sub-
vert them. His subjects were social outcasts, and his working location was
remote from the public. From 1979 to 1982, he filmed, photographed, and
wrote about life within the homosexual underground in the abandoned ware-
houses along the Hudson River. According to his own account, during this
period he "became more active in exploring art as a record of the times
we live in as well as a vehicle of communication between members of cer-
tain social structures and minorities; trusting one's own vision and version
of events rather than the government party line as witnessed in the nightly
news." He also stated, "[I] found increasing hope in my 'differences' and
the gradual simultaneous split from the implemented and enforced and legis-
lated social structure."[1]

During the last decade, Wojnarowicz's differences as a poor, uneducated,
gay man have continued to preoccupy and define his work; the fact that he
recently was diagnosed as having the AIDS virus only furthers his alienation.
Central to his paintings is a struggle to maintain a sense of personal identity
in the face of a repressive society that would like to deny his existence. Con-
fronted by a political climate dominated by a see-no-evil, hear-no-evil philoso-
phy, David Wojnarowicz speaks. He speaks of history, the version we are all
taught, and the very different rendition he knows as *his* *s*tory. "My paintings
are my own written versions of history, which I don't look at as being linear. I
don't obey the time elements of history or space and distance ... I fuse them
all together.... It gives me strength to make things, it gives me strength to
offer proof of my existence in this form." *The Newspaper as National Voodoo:
A Brief History of the U.S.A.* (1986) is a revision of American history read
against the backdrop of the rising AIDS epidemic.

The painting is divided into quadrants by the large central form of a
mummified voodoo doll, arms outstretched in the pose of crucifixion. (As a
child, Wojnarowicz briefly attended Catholic school, of which he recalls "beat-
ings and having to kneel on bags of marbles.") In the lower left quadrant
of the painting is a familiar motif in his work: a bull-riding cowboy, arm raised
as in a rodeo event. Although one reference is clearly to popular cowboy lore,
Wojnarowicz also alludes to the cowboy as a sexual archetype in gay culture:

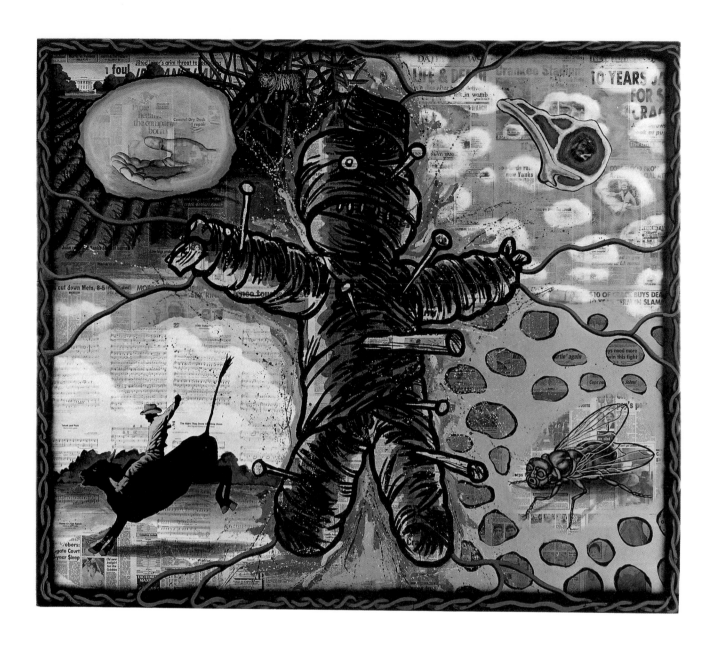

THE NEWSPAPER AS NATIONAL VOODOO: 1986

A BRIEF HISTORY OF THE U.S.A. oil on wood

67 ¹/₂ × 79 ¹/₂

WOJNAROWICZ

"a blue cowboy removing his blue plaid shirt with muscled blue arms and leaning down in a blue naked haze to lick the belly of a shirtless bunkmate."

In the upper left quadrant, just below a postcard of the White House, is a large hand filled with a pool of blood painted on a background of a faintly visible newspaper advertisement for health care. Blood is one transmitter of AIDS, but national health-care policy did little to address the epidemic during the 1980s when President Reagan seemed unable to utter the acronym. In addition, the bloodied hand suggests the stigmata, marks corresponding to the wounds of Christ received by saints during religious ecstasy. "Stigmata" also connotes "stigmatization," or disgrace and ostracism, while a "stigma" in medical terms indicates a history of disease or abnormality. For gays, who are often branded by such words as "AIDS," "homosexual," "faggot," and "queer," stigmatization is not symbolic but real.

In the upper right quadrant the head of Jesus is superimposed on a raw steak. Wojnarowicz has often used the image of raw beef to draw attention to hunger in this country, where abundance and deprivation exist in extremes. In a 1980 gesture of defiance, Wojnarowicz and Julie Hair dumped one hundred pounds of bloody cow bones in a stairwell of the Leo Castelli Gallery. The head of Christ, another recurring image, offers neither solace nor salvation in its disembodied form. The final quadrant, dominated by a giant insect, is perhaps a reference to Wojnarowicz's boyhood habit of retreating to the woods and watching snakes, bugs, and other creatures. He recalls being taught in Catholic school that people in other countries eat such animals.

Ultimately, printed news, which forms the foundation of the painting, is no comfort for Wojnarowicz, for the news media often suppress history and stories of oppressed groups. The majority of the reports in the background newspaper focus on sports; only two articles address the problem of crack, and one deals with the situation of gays.

David Wojnarowicz's work is powerful because it makes no concessions; it forces viewers to confront their psychological and sexual identities, their fears, and their hysteria. In a visual language that is bold and complex, Wojnarowicz turns the world inside out. In place of history he presents alternative truths. In place of complacency he offers action. In response to attempts to silence him he amplifies his gestures of refusal. MM

NOTES

1. Quotations from the artist are from "Biographical Dateline," "Being Queer in America: A Journal of Disintegration," "Postcards from America: X-Rays from Hell," by David Wojnarowicz, and from "The Compression of Time: An Interview with David Wojnarowicz," by Barry Blinderman, in David Wojnarowicz: Tongues of Flame (Normal, Ill.: University Galleries of Illinois State University, Normal, 1990), pp. 62, 84, 109, 114, 118.

PIETIES AND IMPIETIES,

RUPTURES AND REVERSALS:

A BACKGROUND TO ART AND

POLITICS IN THE MODERN WORLD

JOHN HUTTON

The meaning of sign systems, including works of art, is constantly contested; every dominant reading of a painting or poem or play is surrounded by other interpretations, real or potential, which cultural or political oppositions can seize and employ. Every work of art is the confluence of bewilderingly diverse factors; so, too, are attempts to identify and anchor a painting, print, or sculpture to a given reading. To examine the political impact and implications of works of art it is necessary to reconstruct that confluence as far as possible, to see how that impact arose not just from a chosen subject (or political affiliation of the artist) but from what might seem unconnected aspects of form and composition.

When we examine the arts and culture of earlier periods, the term "political art" summons up images of recruiting posters or satirical cartoons, single-minded in their intent and transparent in their message. The comments of Henri Grégoire (1750–1831), French prelate and revolutionary, seem to fit this proselytizing pattern, with their dis-

turbing notion of a totalizing art designed to stamp out good citizens in much the manner that a mold shapes wax candles:

> When one reconstructs a government anew, it is necessary to republicanize everything. The legislator who ignores the importance of the language of signs will fail at his mission . . . Soon the soul is penetrated by the objects reproduced constantly in front of its eyes; and this combination, this collection of principles, of facts, of emblems which retraces without cease for the citizen his rights and his duties . . . forms . . . the republican mould which gives him a national character and the demeanor of a free man.[1]

In Grégoire's time, American and European revolutionaries alike shared the notion that the arts had been consciously employed props of tyranny and despotism. In the United States, Protestant distrust of idolatry and Rousseauist ideas about artistic decadence led many leaders to argue that the arts were mere frivolity at best, tools of oppression at worst.[2] Radical Irish artist James Barry included both Peter-Paul Rubens and the poet Edmund Spenser as agents of a cor-

rupt and brutal social order.[3]

French activists of Grégoire's generation advocated that the new state deliberately use the arts to transform society. Articles in the *Encyclopédie* (1751–72), the voice of discontented *philosophes*, discussed art as an instrument of social change, a way to enlighten and alter popular consciousness.[4] The old regime had produced works that were filled with signs of the monarchy and the church, from the fleurde-lis to the crucifix. Now that domain was to be occupied with a different set of symbols, stressing the slogans and ideals of the new republic. In place of a social and artistic discourse based on images of the divine right of kings, on hierarchy and duty, Grégoire expressed the need for what can be termed a counter-discourse, an alternate system of representations designed to situate and shape permissible social and political thought.[5]

In this cause Classical Greece and Rome were summoned, reinvented actually, to serve as an ideal against which the modern era could be judged. Official art

criticism had already deemed the Classical era a Golden Age,[6] and throughout the middle and late 1700s, oppositionists sought to use such official praise of Classical (and Medieval) antiquity to assert themselves as the rightful heirs of the Greeks and Romans.[7]

We can see this Neoclassical model in Jacques-Louis David's *Oath of the Horatii* (1784–85, fig. 1). The painting can be seen as an explicit rendering of Rousseau's idea of the general will, a voluntary union of individuals into an unbreakable totality. The three Roman brothers swear to their father to return victorious or dead. As they reach for the swords he proffers, the three assume the stance of the blades, symbolically becoming weapons of the state, each voluntarily fusing his individual identity into a collective one. The painting foreshadows the later catchwords of republican virtue: austerity, patriotism, self-sacrifice. Icons of dynastic power are conspicuously absent, as are any references to luxury, ease, or privilege. At the same time, this proto-republic ejects women from any active role: they are marginalized, rendered not so much weak as comatose, unfit for martial fellowship allegedly because they have elevated private family bonds over those of the greater family, the state.[8]

When the *Oath* was exhibited in 1785, it stirred emotions as much for its style as for its subject. David deliberately rejected the elegant, sinuous compositions of his day, breaking the scene and the family into the three brothers at one side, the father in the middle, and the women and children at far right.

For young disaffected artists and intellectuals of 1785, David's picture represented a decisive rupture with old values and ways of seeing and outmoded methods of painting. Its austere style and emphasis on patriotism and self-sacrifice struck a chord; intentionally or not, David's work attracted the dissatisfied, the frustrated, and the angry.[9]

The *Oath of the Tennis Court* (fig. 2), which David began in 1790 but never finished, deliberately develops the sense of rupture, giving it an explicitly political form. The family of the Horatii is replaced by the elected representatives of the French people, who vow never to disband or dissolve until France has a constitution. The explosive moment is rendered by outstretched arms reaching up from every corner as a fresh breeze brings light and air into the stuffy room. Freedom has become an act of will: member after member rises to add his voice to the resolution. As the ancien régime is symbolically negated, a new order begins to coalesce in the center around the president of the assembly, who administers the oath.

The *Oath of the Horatii* depicted a transfer of power and authority from father to sons on behalf of the state; in *Oath of the Tennis Court*, the same gesture, multiplied across the canvas, becomes a sign of mutual and reciprocal duty among citizens to forge a new state. In both paintings, the idea of a break is crucial: old forms and ideas must be physically cracked open so that something better can emerge. The political content of the works is not merely a question of subject matter but of the basic compositional formulas of the paintings themselves. How the subject is depicted indicates the manner in which the subject is to be read.

A later work by David, *Distribution of the Eagle Standards* (1808–10, fig. 3), shows the presentation of new standards, modeled upon those of the Roman Legion, to the elite units of the French Imperial Grand Army. The outstretched arms of the two earlier paintings are repeated here, but carry vastly different significance. The oath is no longer a pledge among family

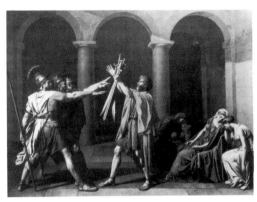

Fig. 1. Jacques-Louis David, *Oath of the Horatii*, 1784–85, oil on canvas, Musée du Louvre, Paris.

Fig. 2. Jacques-Louis David, *Oath of the Tennis Court*, 1790, sketch for unfinished painting, Musée du Louvre, Paris.

Fig. 3. Jacques-Louis David, *Distribution of the Eagle Standards*, 1808–10, oil on canvas, Musée de Versailles.

members or citizens, but becomes instead an avowal of allegiance to a single leader, who himself embodies the nation. Napoleon extends his arm to transmit his authority to his marshals, who in turn reach for the standards. Instead of a new, quasi-egalitarian order forming around a voluntary oath, the scene is rigidly hierarchical. Disorder is limited to the world of the common soldiers, in contrast to the stability of the Napoleonic state.[10] Women were excluded from political discourse even in the relatively egalitarian world of the *Oath of the Tennis Court*; now men, too, become the recipients and objects of political power, subjects rather than citizens in an active sense.

Both the Napoleonic regime and its successor, the restored Bourbon

Fig. 4. Jean-Auguste-Dominique Ingres, *Apotheosis of Homer*, 1827, oil on canvas, Musée du Louvre, Paris.

Fig. 5. Théodore Géricault, *Raft of the Medusa*, 1818–19, oil on canvas, Musée du Louvre, Paris.

monarchy (1814–30), emphasized tradition, order, and hierarchy. The Bourbon regime in particular sought to mine past art forms to provide itself with legitimacy in the eyes of its subjects. The Neoclassicism pioneered by David rapidly lost any hint of its insurgent edge, and under artists such as Jean-August-Dominique Ingres, it became a prop for the dominant social and political powers. Ingres's vocal hostility toward artistic experimentation was well established and longstanding. He demanded, "What do these so-called artists mean when they preach the discovery of the 'new'? Is there anything new? Everything has been done, everything has been found. Our task is not to invent, but to continue."[11] This is misleading, to be sure. Ingres's work exhibits a number of sometimes extraordinary innovations, but they were always mobilized in defense of a closed order, both aesthetically and politically.[12]

Ingres's *Apotheosis of Homer* (1827, fig. 4) exemplifies that trend. Derived from Raphael's *School of Athens* (1509–11), Ingres's *Apotheosis* presents what might be termed an apostolic succession of artists and writers. Homer sits in the center, crowned with a victory wreath by a hovering Nike and framed by the perfect equilibrium of an Ionic temple. The peak of the pediment aligns with Homer's head, just as his body forms the apex of a pyramid below. On the temple steps sit personifications of *The Iliad*, bearing a sword, and *The Odyssey*, holding an oar. Within the sacred walls the artists and poets of history—a mass of more than eighty figures, from Apelles and Aeschylus through Poussin and Shakespeare—fan out from Homer.

In place of David's device of counterposing active human subjects against a static, geometric background, Ingres insists on stasis everywhere in the composition, which is marked by "a synthetic quality that speaks of a willful determination to preserve moribund traditions in the face of the radically new experiences of the modern world."[13]

In opposition to Ingres's mummified Neoclassicism, Romantic artists and critics called for a dynamic art of change and emotion. Compare Ingres's *Apotheosis* to Théodore Géricault's *Raft of the Medusa* (1818–19, fig. 5). Although the formal differences between Neoclassical and Romantic art, such as "line vs. color," have long distinguished the two styles, such divergences also imply a deep gulf between worldviews. In Géricault's art the stable, static world of Ingres is replaced by one of motion and struggle, and the need to bind the present to a Classical past is eliminated.

The painting refers to an event in 1816 when the French frigate *Méduse*, carrying settlers to Senegal, ran aground several miles off the African coast due to the incompetence of the captain (an appointee of the restored Bourbon government). Of 150 crew and passengers forced to take refuge on a makeshift raft, only 15 survived a two-week ordeal at sea.[14]

Géricault's subject was the focus of a bitter political controversy; the liberal opposition cited the disaster and the following cover-up as proof of the corruption of a regime riddled with royal hangers-on. Debate about the painting followed factional lines, with liberals praising the work and royalists attacking it.

Géricault, not unlike David, despised the official art of the Academy and considered it the product of a schooling determined to crush inspiration and produce uniform mediocrity.[15] In the *Raft*, the pyramidal shape formed by the survivors does not signify stasis, but represents human struggle. The protective precinct of the *Apotheosis* is replaced by the open sea, and the pyramid itself is a tangle of human bodies, assembled in desperation as the last survivors signal a passing ship. Géricault sympathized with dissenting liberal groups; his vision of the world as an unjust place in which humans band together to strive for a (secular) salvation is a conscious expression of early nineteenth-century liberal theory. So, too, is the demonstration of Géricault's well-established hatred of slavery. The ship's crew and company of would-be colonizers are saved by the man who tops the pyramid—a slave, one of those they have oppressed. In place of the closed, restrictive world envisioned by Ingres, Géricault offers self-interest as the core of a more egalitarian society.[16]

The struggle for survival in Géricault's work is succeeded by an explicit battle for liberation in Eugène Delacroix's *Liberty Leading the People* (1830, fig. 6). The painting is Delacroix's salute to the revolution that toppled the Bourbon king Charles X in 1830. Over the barricades and those who have fallen in the fighting, Liberty leads a decisive charge, accompanied by a street urchin, a bourgeois student holding a fowling rifle, and urban and rural poor. Liberty herself is a blend of allegory and "woman of the people"; her breasts are bared (a pose traditionally identified with

the Republic, who nurtures her children), and she wears the tattered shift of an impoverished woman. In one hand she brandishes a rifle; in the other she holds the tricolor flag of the republic, banned under the Bourbons.

Delacroix was a Bonapartist, and his painting dutifully calls for a grand alliance of people of all classes. Yet the work disturbed the new government of the "citizen-king," Louis-Philippe, in its emphasis on not only the abstract right to rebel but the physical ability of the people, especially the poor, to do so. Louis-Philippe's regime favored pictures that showed the new king winning power from applauding parliamentarians, not depictions of the masses bearing guns. Delacroix's painting consequently was relegated to storage until the Revolution of 1848.[17]

The fate of *Liberty Leading the People* demonstrates one major difficulty facing those who sought, consciously or not, to depict resistance to authority. It proved easy to suppress paintings that discomfited those in power. (Alternatively, other works could be absorbed and neutralized by those in control once the immediate crisis over them died down; Géricault's *Raft of the Medusa*, for example, was ultimately purchased by the French government.)

By the mid-nineteenth century other pressures worked against overtly oppositional "high art." Oil paintings and sculptures were first subject to screening by official art agencies, such as the annual French Salon, and later were prey to the vicissitudes of the market. Not surprisingly, relatively few among the wealthy, art-buying public had a burning desire for

subversive art. Some artists whose politically radical work was attacked survived professionally only because of the protection of wealthy patrons: Jean-François Millet depended on Alfred Sensier, for example, while the anarchist painter Gustave Courbet owed his livelihood to the conservative art-buyer Alfred Bruyas. In both cases the patron defended the painter but also seems to have exerted pressure on the artist to moderate his work.[18]

Fig. 6. Eugène Delacroix, *Liberty Leading the People*, 1830, oil on canvas, Musée du Louvre, Paris.

Popular prints faced a different set of constraints after enjoying a period of free dissemination. The invention of lithography in 1796 provided dissident artists with a powerful visual weapon. They were able to produce inexpensive prints with new speed, respond to current debates quickly, and distribute their work broadly. The 1830 revolution in France sparked oppositional journals, most notably the satirical publication *Charivari*. Its publisher, Philippon, developed the "pear" campaign, a series of images that revolved around the resemblance of the king's head to a pear. ("Pear" in French was also a slang term for "fathead.") In the hands of the young artist Honoré Daumier, the pear images went far

beyond ridiculing the king's features to an indictment of the entire system. In his *Masks of 1831* (fig. 7), Daumier depicted a central pear faintly bearing a human face surrounded by masks—caricatures of members of the French cabinet and high leaders of the royalist movement. Daumier's point was

Fig. 7. Honoré Daumier, *Masks of 1831*, 1831, lithograph, Art Institute of Chicago.

Fig. 8. Edouard Manet, *The Balloon*, 1862, lithograph, British Museum, Department of Prints and Drawings.

that it made no difference which of them became prime minister: they were all the same; they were all the pear.

An unsuccessful uprising in 1834 (and the attempted assassination of the king in 1835) provided an excuse to clamp down on the opposition. Nearly 250 republican leaders were convicted in summary show trials, and new censorship laws were

imposed on the press. Visual imagery came under specific attack, and prints had to be approved in advance by a government office.

It is frequently argued that the rise of artistic modernism lay in a complex interaction of official repression, patronage pressures, and a gradual disillusionment with all political ideologies. Artists were faced with a constant attempt by those in power to suppress, co-opt, or neutralize their art. At the same time, artists sought room to maneuver by denying or minimizing the political dimension of their work.[19]

Political concerns, however, are not so easily sieved out. They recur throughout the modern period, but as a blend of irony, deadpan mockery, visual puns, and a deliberate mining of established icons. If official art emphasized pieties—homage to nation, church, tradition, and the status quo—other currents in art used what Michael Shapiro has termed "impious" modes of representation. Pious images seek to reaffirm dominant values, to defend stability and order. Impious representations nibble away at the edges of conventions; they deconsecrate them and render them ridiculous as a path to new modes of thought.[20]

An excellent example of the impious artist, Edouard Manet assembled his art from a range of sources, borrowing unacknowledged quotations from earlier masters. But his art is marked by a strong desire to overturn and ridicule traditions. His works are seldom openly polemical (his agonizing prints of the fall of the Paris Commune are an exception), but neither are they the purely technical exercises or elaborate jokes they are sometimes claimed to be.

Manet was politically consistent: under the empire of Napoleon III he was a republican, while under the conservative republic that succeeded the Second Empire he routinely supported the most militant of the middle-class republican parties.[21] He was aloof, often sarcastic, but passionate in his principles and his hatreds.

Manet's 1862 lithograph *The Balloon* (fig. 8) depicts the 1862 celebration of the annual *fête de l'empereur*. The print captures the crowds at the esplanade des Invalides, showing us puppet theaters, booths, and a tethered balloon. Manet's print was rejected for commercial production, most likely because it focused not on the commemoration of the emperor's birthday but on a crippled beggar child in the center foreground. The balloon—a conventional symbol of progress under Napoleon III—is directly above the boy's head. The boy himself is alone; not only do the crowds ignore him, they openly avoid him. The affluent celebrants are played off against the handicapped child, and the apparent mobility (physical, but metaphorically social as well) of the balloon is contrasted to the immobility of the legless boy.[22] The composition of *The Balloon* has been compared to a crucifixion scene; if so, it is one without a resurrection, for in Manet's print there is neither secular nor religious salvation.[23]

Manet's evasive, tongue-in-cheek attitude provided a model for Modernist political art. His canvases reflect the debates of his day as surely as David's do, but unlike the earlier works, their purpose is not to transform society. Instead, Manet sought to defend artists' works from being co-opted and

absorbed, and to open a free space within which they could work.

Impious art can combine negative and positive functions. Mary Cassatt's *Modern Woman* (fig. 9), produced for the 1893 World's Columbian Exposition, is a deliberate recasting of a stock image in Christian art, Adam and Eve eating the fruit of knowledge. Throughout the eighteenth and nineteenth centuries, conservative political leaders had made frequent use of the account of the fall to justify the political subordination of women. Feminists of the era mocked the account and sought to rehabilitate Eve: in the *Woman's Bible*, edited by the American suffragist Elizabeth Cady Stanton (1815–1902), one writer insisted that the story proved that "women had led the race out of the ignorance of innocence into the truth."[24]

Cassatt's work echoes that argument. Cassatt described the painting as "young women picking the fruits of knowledge and science."[25] The official guidebook to the Woman's Building of the Exposition openly asserted the reversal of traditional icons and accompanying ideas: "We have eaten of the fruit of the tree of knowledge and the Eden of idleness is hateful to us. We claim our inheritance, and are become workers, not cumberers of the earth."[26]

The Modernist tactic of reassembling, modifying, and even reversing traditional symbols found expression in Pablo Picasso's Synthetic Cubist collages, begun in 1911. A radical attempt to change the nature of artistic representation itself, Synthetic Cubist works employed actual objects to recreate the artist's experience, rather than depicting two-dimensional analogues of three-dimensional objects. Although the Cubist collages have been treated as exercises in pure form, Picasso's often had pronounced social and political ramifications and reflected his sympathies with Spanish and French anarchist circles. *La Suze* (1912–13, fig. 10) contains not only a label from an aperitif bottle and bits of napkins but also newspaper clippings of a Serbian advance in the bloody Balkan War, which set the stage for World War I, and an account of a massive socialist/anarchist/pacifist rally against that impending war.[27]

Picasso treated politics as a vital component of life and therefore of art, one of many ways in which an artist is bound to his or her own time and place. But if Henri Grégoire imagined art surrounding and shaping the individual, Picasso viewed it as a weapon that the individual artist used to defend and attack:

> What do you think an artist is? An imbecile who has only his eyes if he's a painter, or ears if he's a musician, or a lyre at every level of his heart if he's a poet...? On the contrary, he's at the same time a political being, constantly alive to heart-rending, fiery or happy events, to which he responds in every way. How would it be possible to feel no interest in other people and by virtue of an ivory indifference to detach yourself from the life which they so copiously bring you? No, painting is not done to decorate apartments. It is an instrument of war for attack and defense against the enemy.[28]

Both Grégoire and Picasso saw art tied to greater causes. Grégoire envisioned it as all-encompassing and constraining, but Picasso allied it with the fight against restraints. Their remarks correspond to the concerns of politicized artists in their own times; they help to anchor either end of a modern debate about the relationship of the arts to political and social systems.

The events of World War II produced a climate in which it seemed not only impossible but incorrect to demand any socially transformative art. Rebelling against "socially conscious" patriotic paintings during the war, many American painters argued that political art was no longer conceivable. Robert Motherwell, a member of the bud-

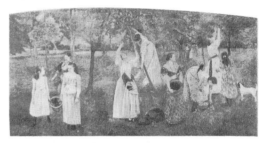

Fig. 9. Mary Cassatt, *Modern Woman*, 1893, mural painted for the Woman's Building, World's Columbian Exposition, Chicago, location unknown.

Fig. 10. Pablo Picasso, *La Suze*, 1912–13, collage with charcoal, Washington University Gallery of Art, St. Louis, University purchase, Kende Sale Fund, 1946.

Fig. 11. James Rosenquist, *F-111*, 1965, four-part construction, oil on canvas with aluminum, private collection, New York.

ding Abstract Expressionist movement, wrote in 1944 that artists could not be political because no cause existed that their art could support. Caught between a philistine middle class and an economically and intellectually impoverished working class, they could paint only for themselves, finding subjects in their own minds.[29]

In addition, influential critics argued that artists could no longer draw upon popular icons or artifacts because they had ceased to represent culture. Only kitsch was left, a mindless mass-imitation of a popular culture that had been debased by commercialism and consumerism.[30] Art could only be self-referential, divorced from the mundane world of physical objects and all their finite and limiting associations. Politics were transient, parochial; true art (apart from its formal values) could only deal with timeless and universal subjects.

Yet, even as the triumph of such art was proclaimed, it was being undermined. An alternate response to a commercial mass culture was to absorb it, play with it, give it monumentality and prestige. Pop art was born in a rebellion against the metaphysical assertions of Abstract Expressionism. Far from

sealing off the arts from the sordid outer world, Pop artists gloried in it, solemnly proclaiming their admiration for soup cans and Mickey Mouse posters. Roy Lichtenstein stated, "The things I parody I actually admire," and added, "The world is outside. Pop art looks at it and accepts this environment . . . and if you ask me how one can love moronization, how one can love the mechanizations of work, how one can love bad art, I answer: I see it, it's here, it's the world."[31]

Outraged critics claimed that the new art glorified the most vulgar and reactionary elements of modern society.[32] Early Pop art did, in fact, carefully edit out any critical comment on the material it reworked. Lichtenstein's blow-ups of panels from war comics refer to the conventions of those comics, not to their subject. Likewise, Andy Warhol's images of race riots, plane crashes, and executions are distanced by multiple steps from the events they note; they are silkscreens, covered with red or orange wash, of reproductions of news photos of the actual incident. The aloof, disengaged works simultaneously glorify and mildly satirize the forms of modern culture without displaying any of the passion or anger of a Manet or a Picasso.

As the 1960s progressed, however, such a detached attitude

became harder to sustain. Pop artists were drawn increasingly into the battles of the day, and their art, with its emphasis on the flotsam and jetsam of modern society, provided a sharp-edged critique. James Rosenquist's *F-111* of 1965 (fig. 11) links Lichtenstein's revisions of war comics with the bitter sculptural assemblages of the 1960s and 1970s by Edward Kienholz and Duane Hansen. Rosenquist juxtaposed an array of cultural icons in an ironic commentary; the fighter bomber appears with consumer products from light bulbs and tires to a hair drier (actually a missile nose cone). In what the artist described as a depiction of acceleration, the viewer follows the attack plane from left to right to the final image of "blinding light, like a bug hitting a light bulb," an atomic blast with a superimposed umbrella.

With the politicization of Pop in the mid-1960s, the Modernist use of ironic juxtapositions and reversals to relieve and comment freely upon the pressures of politics and society began once again to turn outward, seeking to create social ruptures. Rosenquist hoped his painting would lead to rejection of increasingly intrusive technological spy devices: "My idea is that a man will turn to subversion if he even hears a rumor that a lie detector would be used on him in the normal course of business. . . ."[33]

Grégoire sought an art that would mold a new, higher consciousness; Manet strove to negate social restrictions on the artist. David used the vernacular of the Classical past to demand a rupture with the present; Cassatt reversed a dominant myth to assert feminine independence. Picasso culled

everyday bric-a-brac and newspaper clippings to memorialize the brutality of war; Rosenquist assembled the advertising images of a consumer society to warn that misapplied technology has unlimited power to destroy.

The political battles fought by and through visual art are neither fixed in form nor constant in meaning. From the shapes and signs available to them, contending factions will seize whatever they need to make their case. They will sometimes focus on the present and at other times double back to resurrect old styles and conventions, investing them with new import. The forms are transient and quickly discarded; the struggles to which they bear witness are forever new.

John Hutton is assistant professor of art history at Trinity University in San Antonio, Texas.

NOTES

1. Henri Grégoire, *Rapport fait au Conseil des cinq-cents, sur les sceaux de la République, par Grégoire* (Séance du 11 pluviose an IV, 31 janvier 1796), quoted in Lynn Hunt, "The Political Psychology of Revolutionary Caricature," in *French Caricature and the French Revolution, 1789–1799* (Los Angeles: Grunwald Center for the Graphic Arts, 1988), p. 34. I am indebted to Sura Levine for this quote, which helps to shape her essay, "Print Culture in the Age of the French Revolution," in *Representing Revolution: French and British Images, 1789–1804* (Amherst, Mass.: Mead Art Museum, 1989), pp. 6–11.

2. Neil Harris, *The Artist in American Society: The Formative Years, 1790–1860* (New York: Simon and Schuster, 1966), pp. 28–53; see also Lillian B. Miller, *Patrons and Patriotism* (Chicago: University of Chicago Press, 1966), pp. 8–23. This attitude had a long life in American culture. In 1867 Mark Twain wrote, concerning the paintings he saw on a tour of the Louvre, "Some of them were beautiful, but at the same time they carried such evidences about them of the cringing spirit of those great men that we found small pleasure in examining them." Rubens is mentioned by name in this context. *Innocents Abroad*, in *The Unabridged Mark Twain*, ed. Lawrence Teacher, vol. 1 (Philadelphia: Running Press, 1976), p. 78. For Rousseau on the role of the arts, see Jean-Jacques Rousseau, *Politics and the Arts: Letter to M. d'Alembert on the Theatre*, ed. and trans. Allan Bloom (Ithaca, N.Y.: Cornell University Press, 1960).

3. The reference here is to Barry's *Passive Obedience*, a graphite drawing from 1802–1805; the work is reproduced in William L. Pressly, *The Life and Art of James Barry* (New Haven, Conn.: Yale University Press, 1981), p. 149. Barry was a supporter of both the American and French revolutions.

4. See the discussion in James A. Leith, *The Idea of Art as Propaganda in France, 1750–1799* (Toronto: University of Toronto Press, 1965), pp. 49–69.

5. For a discussion of the idea of a "counter-discourse," see Richard Terdiman, *Discourse/Counter-Discourse: The Theory and Practice of Symbolic Resistance in Nineteenth-Century France* (Ithaca, N.Y.: Cornell University Press, 1985), pp. 11–19.

6. Johann Winckelmann, *History of Ancient Art* (1764), *Writings on Art*, ed. David Irwin (New York: Phaidon, 1972), pp. 61–88.

7. Keith Michael Baker, "Memory and Practice: Politics and the Representation of the Past in Eighteenth-Century France," *Representations* 11 (Summer 1985), pp. 134–64; on the role of art criticism in broader social and political critiques of the regime, see also Régis Michel, "Diderot and Modernity," *Oxford Art Journal* 8, no. 2 (1985), pp. 36–51.

8. A necessary starting point for any critique of the *Oath* is Thomas Crow, "The *Oath of the Horatii* in 1785: Painting and Pre-Revolutionary Radicalism in France," *Art History* 1 (December 1978), pp. 424–27, revised in his *Painters and Public Life in Eighteenth-Century Paris* (New Haven, Conn.: Yale University Press, 1985), pp. 211–54. Crow does not, however, deal with the issue of gender privileging in the painting; on this, see Carol Duncan, "Fallen Fathers: Images of Authority in Pre-Revolutionary France," *Art History* 4 (June 1981), pp. 186–202, especially pp. 198–200; Norman Bryson, "Mortal Sight: The *Oath of the Horatii*," from his *Tradition and Desire* (Cambridge, England: Cambridge University Press, 1984), pp. 63–84. It is common in the literature to fuse Crow's reading with that of Bryson: cf., Albert Boime, *Art in an Age of Revolution, 1750–1800* (Chicago: University of Chicago Press, 1987), pp. 392–93. Most recently, Erica Rand has argued that in the *Oath* David took on the specific task of fixing "women in the private sphere, occupied with relational ties." Rand, "Depoliticizing Women: Female Agency, the French Revolution, and the Art of Boucher and David," *Genders* 7 (March 1980), pp. 47–68.

9. Crow, *Painters and Public Life*; contrast, for example, conservative responses to the painting, pp. 214–19, with that of the future revolutionary Gorsas, pp. 226–27.

10. Napoleon himself seems to have been quite aware of — and consciously to have employed — the Davidean oath, in both its original and later (authoritarian) forms. After his escape from Elba in 1815, Napoleon staged an elaborate ceremony, awkwardly fusing the two: dressed in imperial regalia, he swore an oath to the new, more liberal constitution, while the army swore to obey him personally. See J. Christopher Herold, *The Age of Napoleon* (Boston: Houghton Mifflin, 1987), p. 409.

11. Quoted in Lorenz Eitner, ed., *Neo-Classicism and Romanticism, 1750–1850*, vol. 2 (Englewood Cliffs, N.J.: Prentice-Hall, 1970), pp. 133–34.

12. The most thoroughgoing critique of the social role of Ingres remains Carol Duncan, "Ingres' *Vow of Louis XIII* and the Politics of the Restoration," in *Art and Architecture in the Service of Politics*, ed. Linda Nochlin and Henry Millon (Cambridge, Mass.: MIT Press, 1978), pp. 80–91. Ingres's drive to ingratiate himself with those in power had not always been so successful: see Susan Siegfried, "The Politics of Criticism at the Salon of 1806: Ingres' *Napoleon Enthroned*," *Proceedings of the 10th Consortium on Revolutionary Europe* (Athens, Ga.: University of Georgia, 1980), pp. 69–81.

13. Robert Rosenblum, *Jean-Auguste-Dominique Ingres* (New York: Harry N. Abrams, 1967), p. 132. For the manner in which Ingres's art and reactionary politics intersected, see also Carol Ockham, "Astraea Redux: A Monarchist Reading of Ingres' Unfinished Murals at Dampierre," *Arts Magazine* 61 (October 1986), pp. 21–27.

14. For a detailed account of the events, see Lorenz Eitner, *Géricault: His Life and Work* (London: Orbis, 1983), pp. 158–63.

15. Eitner, *Neo-Classicism and Romanticism*, vol. 2, pp. 99–101.

16. The most detailed critique of the politics of

the *Raft* (and of Géricault generally) is, unfortunately, not yet published: Maureen P. Ryan, "Trading in Slaves and Building the Colonies: Rereading the 'Raft of the Medusa,' " delivered at the Sixteenth Colloquium in Nineteenth-Century French Studies, Norman, Oklahoma, October 1990. See also the discussion of the explicitly political paintings (on the struggle for freedom) planned by Géricault before his death: Eitner, *Géricault*, pp. 273–77.

17. The art favored by the Orleanist government is discussed in Michael Marrinan, *Painting Politics for Louis-Philippe, Art and Ideology in Orleanist France, 1830–1848* (New Haven, Conn.: Yale University Press, 1988).

18. Christopher Parsons and Neil McWilliam, " 'Le Paysan de Paris': Alfred Sensier and the Myth of Rural France," *Oxford Art Journal* 6, no. 2 (1983), especially pp. 43–44.

19. See the discussion in Patricia Mainardi, "The Political Origins of Modernism," *Art Journal* 45 (Spring 1985), pp. 11–17. Richard Sennett argues additionally that the industrialization and capitalization of public life in the nineteenth century put a premium on secrecy and evasions: "Only by making your feelings a secret are they safe, only at hidden moments and places are you free to interact." *The Fall of Public Man* (New York: Random House, 1976), pp. 148–49.

20. Michael Shapiro, *The Politics of Representation* (Madison, Wis.: University of Wisconsin Press, 1988), p. xii: "Impious" representations seek to make "the objects of representation problematic and ambiguous, thereby making possible the recognition that what we have regarded as political realities could be rendered otherwise."

21. For a detailed critique of Manet's political views, see Philip Nord, "Manet and Radical Politics," *Journal of Interdisciplinary History* 14, no. 3 (Winter 1989), pp. 447–80. In this regard, see also Ewa Lajer-Burcharth, "Modernity and the Condition of Disguise: Manet's 'Absinthe Drinker,' " *Art Journal* 45 (Spring 1985), pp. 18–26; Jacquelynn Baas, "Edouard Manet and 'Civil War,' " in ibid., pp. 36–42; John Hutton, "The Clown at the Ball: Manet's *Masked Ball of the Opera* and the Collapse of Monarchism in the Early Third Republic," *Oxford Art Journal* 10, no. 2 (Fall 1987), pp. 76–94.

22. The most detailed study of this work is Douglas Druick and Peter Zegers, "Manet's 'Balloon': French Diversion, the *Fête de l'Empereur* 1862," *The Print Collector's Newsletter* 14, no. 2 (May–June 1983), pp.

38–46. Manet's use of a balloon ride as a trope for progress is also discussed in Patricia Mainardi, "Edouard Manet's 'View of the Universal Exposition of 1867,' " *Arts Magazine* 54 (January 1980), pp. 108–15.

23. George Mauner, *Manet, Peintre-Philosophe* (University Park, Penn.: Pennsylvania State University Press, 1975), pp. 174–76. The closest reading of Manet's religious views is still in manuscript: Lisa A. Passaglia, "Edouard Manet and *Christ Mocked*: A Study in Historical Perspective," manuscript copy. See also Michael Paul Driskel, "Manet, Naturalism, and the Politics of Christian Art," *Arts Magazine* 60 (November 1985), pp. 44–54. Druick and Zegers point out that the annual balloon ascensions were part of Bonapartist propaganda. They bore the Emperor's monogram and played the role of "the profane counterpart to the Assumption of the Virgin" (p. 41). The balloonists sometimes showered presents on the crowds below as proof of the benevolence of the empire.

24. *The Woman's Bible*, vol. 2 (New York: European Publishing, 1898), pp. 165–66.

25. *Cassatt and Her Circle*, ed. Nancy M. Matthews (New York: Abbeville Press, 1984), p. 238.

26. Maud Howe Elliott, "The Building and Its Decoration," in *Art and Handicraft at the Woman's Building of the World's Columbian Exposition* (Boston: Boussod and Valadon, 1893), p. 23; see also Griselda Pollock, *Mary Cassatt* (New York: Harper and Row, 1980); Jeanne Madeline Weilmann, *The Fair Women: The Story of the Woman's Building, World's Columbian Exposition, Chicago, 1893* (Chicago: Academy Chicago Press, 1981), pp. 313–22; Sally Webster, "Mary Cassatt's Allegory of Modern Woman," *Helicon* 9 1, no. 2 (Fall/Winter 1979), pp. 39–47. The mural forms the subject of my article, "Picking Fruit: Mary Cassatt's *Modern Woman* and 19th Century Feminist Theory," in progress.

27. Patricia Leighton, *Re-Ordering the Universe: Picasso and Anarchism, 1897–1914* (Princeton, N.J.: Princeton University Press, 1989); see chapter 5, "The Insurrectionary Painter: Anarchism and the Collages, 1912–1914," pp. 121–42; a slightly revised form of the same argument appears in her "Picasso's Collages and the Threat of War, 1912–1913," *Art Bulletin* 67 (December 1985), pp. 653–72.

28. Pablo Picasso, interview with Simone Téry, quoted in Alfred H. Barr, Jr., *Picasso: Fifty Years of His Art* (New York: Museum of Modern Art, 1980), pp. 247–48.

29. Robert Motherwell, "The Modern Painter's World," *Dyn* 6 (November 1944), p. 9. This era is discussed in Serge Guilbaut, *How New York Stole the Idea of Modern Art: Abstract Expressionism, Freedom, and the Cold War*, trans. Arthur Goldhammer (Chicago: University of Chicago Press, 1983); David and Cecile Shapiro, "Abstract Expressionism: The Politics of Apolitical Painting," *Prospects* 3 (1976), pp. 175–214.

30. The classic argument here is Clement Greenberg, "Avant-Garde and Kitsch," *Partisan Review* 6, no. 5 (Fall 1939), pp. 34–49; Theodor Adorno made a similar attack (in this case on jazz) in "Perennial Fashion—Jazz," reprinted in his *Prisms*, trans. Samuel and Shierry Weber (Cambridge, Mass.: MIT Press, 1986), pp. 121–32.

31. Quoted in Donald Kuspit, "Pop Art: A Reactionary Realism," *Art Journal* 36, no. 1 (Fall 1976), pp. 31, 36.

32. In addition to Kuspit, see Max Kozloff, " 'Pop' Culture, Metaphysical Disgust, and the New Vulgarians," *Art International* 6, no. 2 (March 1962), pp. 34–36.

33. James Rosenquist, "What Is the F-111?" (interview with G. R. Swenson), *Partisan Review* 32 (Autumn 1965), pp. 589–601.

READING

THE WRITING

ON THE WALL

REBECCA SOLNIT

Who is the public? How do individuals affect their society and affirm their membership in it? Who controls public spaces and political issues? When do images and performance become politics and media? How does the art world fit into the culture at large? I sit down to write this essay on political art and public space the week President Bush started the bombing war with Iraq, and the war brings to a head all the issues such art has raised. One moment stands out: the day after the war began, tens of thousands of my fellow San Franciscans spilled out onto the streets to express their outrage with marches, chants, and blockades, and with signs, posters, spray paint, costumes, body bags. During rush hour, when thousands of commuters encountered thousands of activists, I found myself listening to the bombing of Tel Aviv on the shortwave radio of a photojournalist friend. Police and demonstrators exchanged the bits of news that they picked up about this disaster on the other side of the world, briefly spectators rather than participants in that day of terrible history. In San Francisco, most of the population seemed to be on the

streets; in Tel Aviv, nearly everyone was inside a sealed room wearing a gas mask; the literal public space was warped and augmented by the shared conceptual space of live broadcasts listened to by millions. The schismatic solidarities created by street protest, the universal isolation engendered by air-raid alerts, and the global village generated by satellite-transmitted reportage were a volatile combination, a provocation to consider the relationship between government, community, and media.

•

Like a monster in a 1950s horror movie, the media have engulfed art and politics in recent decades, obliterating the boundaries that used to separate them and generating a mutant culture of contention (fig. 1). At the beginning of the 1980s, an actor became president of the world's greatest military power, and at the end of that decade, a playwright became president of one of the world's newest democracies. Modernist distinctions between high and low art collapsed (except in the title of the 1990 Museum of Modern Art show); the categories of avant-

garde and kitsch both seemed obsolete. A true advance guard, after all, marches at the head of an army; in the maelstrom of these times, people march—or rather, flee, wander, tumble—in every direction. Notions of both the public and the individual have been problematized by critical theory. Changing demographics, multi-cultural affirmations, and a plethora of rights movements (feminism, gay liberation, activism by the disabled) have dissolved the idea of a homogeneous public with common interests, as has the Far Right's assault on women, gays, artists, and economic justice. Voter apathy and the privatization of space, industry, and culture have further dismantled the possibility of a pub-

Fig. 1. Cindy Reiman/Impact Visuals, *Bush, Bush, Bush*, January 19, 1991. Signs carried by peace march participants, San Francisco.

lic in the traditional sense. The public art movement that arose in the 1980s became codified for bureaucratic ease and lost many of its ardent supporters as well as its initial confidence as a contribution to urban culture. In short, old categories melted and new rifts opened up. In the wake of these ruptures, new kinds of art emerged, most significantly a rejuvenated art addressing social and political concerns. In its strongest manifestations, this art invaded the eroding arena of urban public space (and its partial replacement, the conceptual public space of the media).

In 1966 the landscape historian J. B. Jackson wrote:

> We must change the existing public landscape if we are once more to have a political identity.... The Federal government ... is everywhere destroying public gathering places near or around federal buildings. The very term "public building" has become a contradiction: no one in his right mind now goes into a public building except on business. The question is, of course, what form the public gathering place should assume. The Communist countries seem to be devising their own versions. One thing can be said: there must be many more such places, large and small, scattered throughout our communities.[1]

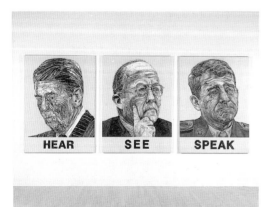

HEAR SEE SPEAK

Fig. 2. Robbie Conal, *Hear, See, Speak*, 1987, oil on canvas (prototype for poster), courtesy of Jayne H. Baum Gallery, New York.

One of the most impressive spectacles of the 1989–90 winter of revolution in the communist countries of Eastern Europe was that of people claiming their public spaces: Saint Wenceslas Square in Prague, the Berlin Wall, the streets of Romania. The timeworn cities made these uprisings possible: there were squares in which to gather, statues to topple, walls to sledgehammer, and almost everywhere a human scale in contrast to the monolithic centralization of the Eastern Bloc. Public space and public symbolism seemed central to the effectiveness of this citizenry, perhaps even critical to the ability of people to act as citizens.

The huge turnout of antiwar activists in San Francisco a year later reflected not only the traditional radicalism of the region but also the quality of space in this compact pedestrians' city of wide sidewalks, avenues, and plazas. In Los Angeles such an uprising would be virtually impossible: where would you gather? where could you march? who would see you in this automegalopolis? Car-based lifestyles have eroded civic space, not only in Los Angeles but in much of the United States, where billboards and commercial-strip signage are the only information absorbable in the space and at the speed of a driver. The kind of shift in urban planning that Jackson refers to is one that eradicates citizenship. The First Amendment's guarantee of freedom of assembly seems to have been done in by urban design. Much official public art now goes into bus stops, train stations, and buses, for private persons shuttling from interior to interior; L.A.'s most successful official public art form has been the freeway-side mural.

The other notable public art phenomenon in Los Angeles has been entirely unofficial. Painter Robbie Conal has saturated that city (and many others) with terse, harsh political posters. His first, *Men with No Lips*, was a quartet of impasto portraits of White House figures with the title caption, which he printed in an edition of 1,000 and plastered throughout the city just before the Iran-Contra scandal broke in 1986. Conal traveled to New Orleans during the Republican Convention in 1988 to poster the city with images of George Bush inscribed "It Can't Happen ... Here." He reached more cities with a poster of Oliver North captioned "SPEAK," one of Bush and Dan Quayle labeled "PLAN AHEAD," and others (fig. 2). "The theme that runs through all my work," Conal said in 1988, "is the accountability of people who have power over other people's lives."[2] At one point, the city of Los Angeles, which tolerates entertainment posters, initiated prosecution proceedings against Conal for his activities. Conal's work, like that of Barbara Kruger (pp. 49–52), Hans Haacke (pp. 36–38), Sue Coe (pp. 29–31), David Wojnarowicz (pp. 71–73), Hachivi Edgar Heap of Birds (see p. 14, fig. 7), and anonymous guerrilla artists, clarifies the polemical diversity of the public by taking an unequivocal position on public issues. Although most of the artists named have received support from the art world and, in a few cases, public art programs, their work demands that public art be redefined.

In *Common Sense* (1776), Thomas Paine declared, "Some writers have so confounded society with government, as to leave little or no distinction between the two;

whereas they are not only different, but have different origins. Society is produced by our wants, and government by our wickedness; the former promotes our happiness positively by uniting our affections, the latter negatively by restraining our vices." This distinction is often—and necessarily—evaded by public art programs, which must steer a course between the experimentalism of art and the don't-rock-the-boat desires of government at all levels. Although in Paine's monoculture, government was divisive and society unifying, in our more diverse culture, society is splintered, and preserving harmony is a central governmental function—"the manufacture of consent," it has been called. In citing Paine, however, I do not mean to confound the NEA with the CIA, but only to suggest that public art takes shape under enormous and largely unacknowledged strictures. At its best, agency-sponsored public art, which I prefer to call civic art, generates and nurtures a public; at its nadir, it placates and offers platitudes for a generic citizenry of dubious existence. The publicness of public art is often determined by geography, but it might better be defined by a conjunction of geography and ideology or by a reminted vocabulary: "civic art" for the art commissioned by government-allied public agencies; "art-in-public-places" as a purely geographical determinant; "public art" for art that actually addresses public needs and issues (art-in-public-places, after all, is not necessarily public art, as innumerable Henry Moores bear witness); and unofficial public art such as Conal's—public art that engages in polemics—could be called "cul-

tural activism," a term used by Brian Wallis in association with Group Material's *Democracy* project.[3]

After all, are the relatively formal earthworks by Robert Morris from the 1960s and 1970s more public art than his hydrocal Holocaust paintings (pp. 56–58) of the 1980s? Traditional media and criteria for permanent civic art virtually rule out the possibility of directly confronting urgent political issues such as genocide and nuclear annihilation. Quixotically, publicly sited works such as Morris's observatory in the Netherlands or his reclamation project in Washington state are usually about timeless private experience and the spiritual and sensory, while his Holocaust-imagery paintings for galleries or museums graphically engage the sociopolitics of the time. The earthworks are more publicly accessible, but less about public issues. Relatively protected exhibition spaces allow for a rawness impossible in civic art; public issues unfold most directly in private space. Hans Haacke's *Oelgemaelde, Hommage à Marcel Broodthaers* (p. 37) addresses contemporary public issues and a Paine-like distinction between society and government by facing off an ornate painting of a pronuclear world leader and a photojournalistic image of a huge antinuclear demonstration. Such biting work would never be commissioned as civic art. Robert Arneson's city-commissioned bust of assassinated San Francisco Mayor George Moscone was rejected for its irreverently graphic pedestal decorations, including a handgun imprint and references to the assassin's junk food defense. Because it engaged public controversy, the work was barred from

official public space.

Barbara Kruger's foray into public art in Los Angeles is another fascinating case (fig. 3). Commissioned by the Museum of Contemporary Art to create a mural for its Temporary Contemporary building in conjunction with the *Forest of Signs* exhibition (1988), Kruger proposed a vast flag with the Pledge of Allegiance in large letters surrounded by questions in smaller type. The Temporary Contemporary is located on the edge of Little Tokyo, and the mural's reference to issues of patriotism profoundly offended many Japanese-American locals who remembered

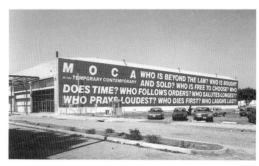

Fig. 3. Barbara Kruger, *Untitled (Questions)*, 1990, mural on south wall of Temporary Contemporary, Museum of Contemporary Art, Los Angeles.

the racism, challenges to their loyalty, and internment camps of World War II. Perhaps Kruger was unaware of this chiefly West Coast history, but whatever the circumstances, an artwork that in a neutral, interior exhibition space addressed a self-selected public, outdoors addressed the public of Little Tokyo. The homogeneous America that Kruger imagined as needing to question authority dissolved into the culture-specific America that had been questioned by authority. Kruger responded to the community's concerns by rewriting the text, and what might have been considered censorship in

a private space became an act of community negotiation in a public one. The 1980s was less the decade of the death of the author, à la Roland Barthes, than of the dissolution of the artistic ego into the demands of collaboration, site-specificity, contextual issues, and guerrilla art.

It could be argued that public places belong to everyone and that polemical art is inappropriate there. The fact that the imagery of these arenas is created largely by advertisers suggests, however, that the determinant is economics, not ecumenical democracy. Moreover, in public spaces, where advertising and political iconography jostle for the loyalties of the citizenry, the equivocation of art may empower viewers simply by letting them draw their own conclusions. Work in public places by artists such as Jenny Holzer (pp. 43–45) and Kruger often functions this way, making the viewer an active partner in the construction of meaning (or the rejection of pseudo-meaning). Until recently, artists most often participated in political issues by enriching and complicating the issues rather than taking clear-cut positions on them. Such acts as Andy Warhol's insertion into high-art spaces of images of National Guardsmen attacking black civil rights activists are inherently political, but they do not advocate a particular response. Similarly, Warhol's images of Mao (pp. 68–70) function less as a commentary on politics than on the way political meaning is distorted in the process of its communication—on the way the media become generators rather than transmitters of meaning. Paradoxically, the most political work can be the most limit-

ing: invested in convincing the viewer of certain truths and encouraging specific actions, it often adapts the strategies of advertising and political rhetoric to enlist its audience, rather than simply to provoke. A counterpoint to this competition for allegiance might be the street demonstration, in which the same citizenry takes over the function of arguing political issues via theater and visual images.

How does civic art generate and nurture a public? One way is by creating public space in which people experience themselves as citizens, as part of a polity, not merely as individuals. In this regard, utilitarian installations—benches, paths, plazas, land reclamations—may be more important than decorative additions. As Jackson states, "We must change the existing public landscape if we are once more to have a political identity." More and more, civic art is becoming an art of place design, integral to the landscape or architecture and part of its planning process, instead of an ameliorative addition to an alienating space. It is an art that shapes rather than represents, and in this respect, it may encourage political speech, but without speaking loudly itself. For example, when the San Diego–based artists Helen Mayer Harrison and Newton Harrison were asked to propose a public art-work for Baltimore, they offered *Baltimore Promenade*, a long walkway that would promote pedestrian traffic, connect economically diverse areas, and reunite the city with its harbor. In contrast, Richard Serra's *Tilted Arc* was attacked by government workers who had to live with it as much for its disruption of the public space of the plaza as for its

aesthetics and what they perceived as the undemocratic process of its selection.

Maya Lin's 1982 *Vietnam Veterans Memorial* still stands as the greatest achievement of civic art, a mirror-opposite of the Berlin Wall in its function as a symbolic landmark. The memorial is first of all a place to come to, second a reminder of what might otherwise be obliterated history, and third, and perhaps most important, a piece that engages people more as participants than as an audience. Viewers not only look at the wall, they bring things to it, take rubbings from it, search it for names of family members. Controversial at first, Lin's monument has become a major feature of the landscape of national identity.

Similarly, the *Names Project* quilt, started by Cleve Jones in 1986, involves people across the country and pays tribute to the individuals who constitute the statistics of the AIDS catastrophe. The quilt consists of thousands of panels sewn by friends, lovers, and family members of those who have died as a result of the disease. As an assertion of gay identity and the myriad tragedies of AIDS, the work can be construed as cultural activism; however, its focus on the private meaning of each death and its gentle, traditional medium seem to unite rather than polarize. Exhibited nationally, the quilt is a public artwork that transcends place. Much as the 1970s and 1980s focused on the ways in which the personal is political, works such as the *Names Project* quilt concern the converse, that the political is personal and that public issues reach deeply into all our private lives.

A less well-known example of

cultural activism is Jerry Burchfield and Mark Chamberlain's project in Laguna Beach, California, *The Tell* (1989, fig. 4). The work was the culmination of nearly a decade of community art activism against a massive freeway that would have destroyed the last major block of open space in Orange County. *The Tell* was a several-hundred-foot-long plywood wall covered in photographs brought by members of the community (80,000 photographs in all, most of them family and vacation snapshots). Installed for several months at the entrance to the canyon threatened by development, the wall undulated like its surroundings. It became a focal point for rallies and a march against the freeway proposal, which was finally defeated in 1990. Although it had two central artists, the project empowered the rest of the community to participate in determining its future. In many respects it distributed the function of the artist to a larger group.

The critic Arthur Danto writes, "In an odd way, art was a way of taming these barbaric practices [Dionysian rites], putting them at a kind of distance so that instead of participants there could be an audience."[4] Conventional public art is conceived to be a kind of gift to the people, but the highest form of public art is that which engenders public participation rather than an audience's passivity. In a time in which participation is eroding in every sphere of society and consumption is promoted as the primary form of self-expression, such empowerment is increasingly rare and precious. The greatest gift of public art is not one given by administrators or artists to an audience, but the gift people give to each other in the creation of a community. Concomitantly, the most successful public work of art is one that generates the strongest conversations rather than one that provokes or offends no one. Instead of trying to get the sculpture without the controversy, administrators and artists might speculate on how to get the controversy without the sculpture.

Whatever the elitism of Serra's *Tilted Arc*, the conversations it generated between workers, administrators, and the art world were a profound occasion of democracy. The courtroom exercise of testifying for or against the piece's survival in situ was a fascinating spectacle of accountability. Like the Mapplethorpe exhibition obscenity trial in Cincinnati, the *Tilted Arc* trial demanded that art-world denizens describe their values and ideas to people from radically different contexts, and that the art world justify itself as a valuable part of a larger community. Sadly, questions of real merit were asked under conditions of such rancorous threat and intolerance that they prompted more defensiveness than self-examination. At the same time, the battles made unavoidable the conflicts between artists and administration (in Paine's terms, society and government). These conflicts had been evident in other areas, emphasized by pro-choice feminists, AIDS activists, pacifists, and environmentalists. The battles made the art world as a whole acknowledge for the first time that both art and government were inherently political territories with separate agendas. Recognition that art was political resulted in greater interaction with other aspects of the political sphere. Artists found themselves in the midst of the new culture of contention.

Conversation both ruptures and connects. It arises out of conflict and is the vehicle of peaceful change. Two voices are needed to express a difference; a disagreement can be resolved only if the parties voice their concerns. Preserving a facade of harmony means enforcing silence: as the maternal admonition goes, "If you don't have anything nice to say, don't say anything at all," and silence, as ACT UP declares, equals death (fig. 5). This country, with its consolidation of power and opinion at the center, peculiarly fears differences of opinion. Its media lay claim to objectivity rather than laying out their loyalties, as at least print media do in most other countries. Still, if community is generated from conversation, contentions are a critical contribution to the existence of a public and to public places. Insofar as the publicness of public art is conversational, the official version of public art is too often an assertion handed down from above, a monologue that views overly lively dialogue as threatening to the goal of getting the work in place. Unofficial art occurs on a horizontal plane of debate and is less inclined to soothe than it is to provoke response.

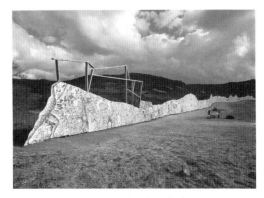

Fig. 4. Jerry Burchfield and Mark Chamberlain, *The Tell*, 1989, Laguna Beach, California.

In this conversational scheme, visual art joins demonstrations, advertising, and official iconography (flags, for example) in the public contest of meaning. Although public spaces are irreplaceable, they are also augmented and warped by the media coverage that mediates the public and private experience of them. The occupation of Tiananmen Square, the fall of the Berlin Wall, the bombing of Tel Aviv, and the antiwar marches in San Francisco were all broadcast around the world, and in some way common information made a community out of their audiences. The ultimate territory for the public and the political is the individual imagination, and it is the ability of images such as the Goddess of Democracy in Tiananmen Square or the *Vietnam Veterans Memorial* to capture the imagination that gives them a public power transcending their locale. In this respect the media often become the real sites of all kinds of public art: by immortalizing a frail figure in a stand-off with a line of tanks, by making Andreas Serrano's *Piss Christ* the most widely known fine art photograph of 1990, or by circulating images created for the media by activist groups such as Green-

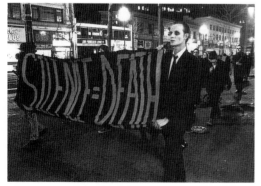

Fig. 5. Rachel Johnson/Impact Visuals, *ACT UP: Day of Disaster*, January 28, 1991. Activists in death garb march through San Francisco protesting the military budget/AIDS budget.

peace, they vastly extend the reach and lifespan of all forms of public activity.

The centrality of the media is alarming, as well, because media enterprises have their own agendas and respond to their own pressures, and because media information tends to encourage spectatorship rather than participation. In this respect these communication systems resemble galleries and museums, and the strength of artists' collectives like San Diego's Border Arts Workshop and New York's Group Material lies in their ability to work both inside the art world and the media and outside them, on streets and in communities. In this scheme of things, public space remains crucial to democracy as one of the few alternatives to the institutions of culture and communication, an unmediated space in which anyone can try to start a conversation.

Rebecca Solnit is a West Coast critic, essayist, and activist.

NOTES

1. J. B. Jackson, "The Public Landscape," in *Landscapes* (Boston: University of Massachusetts Press, 1970), pp. 157–58.
2. Robbie Conal quoted in *Newsweek*, August 29, 1988, p. 58.
3. Brian Wallis, ed., "Democracy and Cultural Activism," in *Democracy: A Project by Group Material*, Discussions in Contemporary Culture, no. 5 (Seattle: Bay Press, 1990), p. 8: "To the extent that activism has, of necessity, become bound up with the creation of legible and effective images, this new style of politics might be called 'cultural activism.' Cultural activism might be defined simply as the use of cultural means to try to effect social change. Related to activist programs initiated by artists, musicians, writers, and other cultural producers, such activism signifies the interrelatedness of cultural criticism and political engagement."
4. Arthur Danto, "The Politics of Imagination," in *Art Issues* (Los Angeles), no. 6 (October 1989), p. 9.

Special Interests:

Art and Politics

In the 1980s

CAROL SQUIERS

During the 1980s, politics made a prominent appearance as a valid and significant subject for art. Yet when discussing this development, it is important to account for not only how political subject matter functions in art but also how artists who make political work influence and alter the politics of art. In the 1980s the restricted, clubby art world, in which white men traditionally were the creators and deal makers and white women were the support staff, expanded to include a range of new players. At the same time that conservative political activists around the United States were trying to close down options for women, minorities, and gays, these groups were becoming visible in the art world in ways they never had before. Some of this new prominence, especially for women, resulted from gains made after years of political agitation. Other groups, such as gay men, garnered attention by decrying government censorship and inadequate medical care in newly energized protests that straddled the boundaries between the medical establishment, art community, religious hierarchies, and federal and local governments. The 1980s are remarkable for the way in which

social agitation occurred along with artistic transformation. For although political art received attention and respect in the 1980s, it was not the content or form of the art alone that was political. Rather, politics affected the very fabric of the art world's social relations, throwing into high relief not only continuing inequities but real gains as well.

The group that made the most impressive and powerful strides in the art world in the last decade were women, who broke an invisible but resilient sex barrier in top galleries, museums, and international exhibitions. Women also made the most politically progressive and visually compelling art, which appealed both to the core group of active collectors and art professionals and to the general, gallery-going public. While conservative activists such as Phyllis Schlafly advocated a return to traditional female roles and behavior, artists such as Barbara Kruger (pp. 49–52), Cindy Sherman (pp. 62–67), Jenny Holzer (pp. 43–45), Sarah Charlesworth, Laurie Simmons, and Sherrie Levine adroitly demonstrated that women's place was in the public eye.

But it was not just the content of

their art that was political. The rise of women as important artists, who were not simply doing female versions of male art forms, i.e., painting and sculpture, helped begin a social revolution in the art world. They challenged the acceptable content, form, and raw materials of art as well as the very definition of who could enter the halls of culture as a player rather than as a spectator. [1]

Racial minorities, especially African-Americans, also gained visibility in the upper reaches of the art world during the 1980s, but they suffered a bleaker fate than women. The young black artist Jean-Michel Basquiat (pp. 22–25) was an especially spectacular success. He penetrated the bastion of painting, first with graffiti, and then with his more conventional primitivist/expressionist work, which read as high art and outsider art at the same time. His death from a drug overdose in 1988 at the age of twenty-seven not only ended his career, it also pointed up the harsher reality that even prominent minority artists faced in dealing with sometimes crushing professional pressures.

Indeed, none of the other graffitists were as successful as Bas-

quiat, having failed to transform what was essentially a guerrilla art form into an art of the salon. Graffiti on canvas was ultimately nonsensical in a gallery setting, precedents from Marcel Duchamp and others notwithstanding. Its power lay in its outlaw existence and its defiant proclamation of authorship and even personhood. It simultaneously decorated and defaced New York's subways and buildings. To make something that was often and publicly reviled as an eyesore into a commodity that uptown folks would pay good money for was a task that was beyond the dealers and curators who tried. The once-praised graffiti artist Futura 2000 had to go to work as a bicycle messenger when his short-lived art career fell apart, although he has recently begun to make a comeback. Then, too, social relations between graffitists from New York's minority ghettos and well-heeled white denizens of pricey Manhattan real estate could not have been easy. The artist has always been indulged as justifiably eccentric and temperamental. But kids with spray cans as their tools, wearing the garb and talking the lingo of the ghetto, might not have been a proper embodiment of the artist in what is still the essentially all-white world of the arts.

Adrian Piper, who has had a presence in the art world, especially in performance, since the early 1970s, is one African-American political artist who has begun to receive mainstream attention. The text of her work has been largely about race relations, which were not terribly compelling to the art world until the later 1980s. By then, racism had been reinscribed in the body politic as a

viable social practice, first by the Reagan administration's attacks (especially on "welfare cheats," a coded term that white America read as racially specific), and then by George Bush's extraordinarily racist presidential campaign in 1988, in which "crime" was the racial code. Public protest over administration sanction for racism and some traumatic and highly publicized racial killings—particularly in New York's Howard Beach and Bensonhurst neighborhoods—put race prejudice back on the national agenda as a viable social problem. Until then, racism as a subject for art seemed an embarrassing case of reheated black-power politics left over from the 1960s. Artists like Piper (and other lesser-known artists, such as David Hammons and Pat Ward Williams, many of whom were included in *The Decade Show* held jointly by the New Museum of Contemporary Art, the Studio Museum in Harlem, and MOCHA [the Museum of Contemporary Hispanic Art] in 1989–90) began getting more attention once the art world acknowledged that race prejudice and bigotry were not passé. Given these social and political developments, Piper and the others began to look like very prescient artists.[2]

The third group that made a political mark on the art world in the 1980s was gay men, both as artists and as activists. Gay men came to public attention by two tragic paths: government censorship and government neglect. When conservative politicians attacked photographer Robert Mapplethorpe, the art world found itself unpleasantly taken by surprise. He was well known and commercially successful, especially in

circles where fashion and society overlapped with high culture, but his work had received little serious critical support and was regarded as both stylistically and politically reactionary by the left intellectual/ theoretical branch of the art world. Yet suddenly the art community was confronted with conservative politicians and their supporters pointing to Mapplethorpe's images as archetypically gay, i.e., immoral and offensive. Although it was clear that gays and art needed to be defended, the art community had a difficult time doing so—until its members had to testify at the obscenity trial of Cincinnati's Contemporary Arts Center and its director, Dennis Barrie—largely because it was the problematic Mapplethorpe who was at the center of the controversy.

The other social and political issue gay men made visible, both inside and outside the art world, was AIDS. Although it has decimated the ranks of artists and other art workers, AIDS has politicized those remaining to a degree unmatched since the Vietnam War protests of the 1960s and early 1970s. AIDS has influenced the content of art, affected the social relations of the art world, and made vocal activists of people who might otherwise be quietly working as artists, critics, or art historians. Artists and their galleries have contributed thousands of dollars' worth of art to auctions and sales to benefit those with AIDS. Most painfully, artists who themselves are HIV-positive are making work about their predicament, their anger, and their despair.

Prominent among them is David Wojnarowicz (pp. 71–73), who makes densely layered composite

pieces about sex, death, and politics in photographs, paintings, performances, and installations. As a PWA (Person with AIDS), Wojnarowicz has incorporated his personal tragedy into his art. The volatility and precise aim of his outrage and anger, however, brought immediate wrath from the political right wing. His bitter, auto-biographical essay written for a show on AIDS at New York's Artists Space entitled *Witnesses: Against Our Vanishing*, curated by artist Nan Goldin, spurred the National Endowment for the Arts to cut off funding to the exhibition. There was a loud outcry over the essay, especially about its attacks on Cardinal John O'Connor. The funding was later reinstated with the fiat that no money go to publication of the show's catalogue.

Only months later, a body of Wojnarowicz's work was attacked by Rev. Donald Wildmon's funda-mentalist American Family Association. Wojnarowicz responded by taking Wildmon and his group to court and won an injunction against their unlawful reproduction and misrepresentation of his art. All of this shows that contemporary culture has become a political battle-ground. Although it seems that visual artists could not do much to actually change the world, the right wing's attack on art shows how pro-foundly it understands the power of representation. Pictorial represen-tation was the most important foun-dation of Ronald Reagan's two-term presidency, and the control of repre-sentation, from photo opportunities at the White House to the Meese Commission's countrywide hunt for pornography, was mandated from the beginning of the Reagan administration.

Indeed, the only way to under-stand political art produced in the 1980s is to view it within the politi-cal context of our time, especially within the movements for social change that repeatedly questioned the status quo of postwar America: the civil rights movement in the 1950s, anti–Vietnam War protests, the women's movement, the short-lived radical Hispanic and black liberation groups, gay and lesbian rights protests, the antinuclear movement, opposition to apartheid in South Africa, and environmen-talism. Much of today's political art is descended, in idea and sentiment at any rate, from those seminal movements. Still, only a limited number of political artists have been given official sanction, especially in comparison to the plethora of artists who make medi-ocre but apparently acceptable painting and sculpture and enjoy successful careers doing so. Many more political artists work outside the elite nexus of galleries and museums, and many of them see their true constituency as the gen-eral populace rather than the art world. By going one step farther, and by making not just political but activist art, these artists directly affect social change.[3]

Even without claiming such instrumental ambitions, political art has had a difficult time gaining acceptance in the higher reaches of the art establishment. One signal setback occurred in 1971, in the now-legendary incident in which the Guggenheim Museum canceled an exhibition of work by Hans Haacke (pp. 36–38) because of three pieces, two of them on the topic of real estate, property val-ue, and individual and corporate ownership.[4] Even though Haacke

proposed no solution to the pattern of slum ownership exposed in these pieces, but was merely presenting information, the work was deemed by Guggenheim director Thomas Messer to violate a ban on the museum's participation in "extra-artistic activities or sponsor[ing] social or political causes."[5] Further, Messer saw the admission of this work as a direct threat to the museum, stating that by canceling Haacke's show, he had fended off "an alien substance that had entered the art museum organism."[6]

The vision of political art as a biological pollutant hung over the gallery/museum sector of the art world throughout the 1970s. That decade's vaunted pluralism was more accepting of things like pat-tern painting and diaristic confes-sionals. In 1973, the problem of making and exhibiting art that was outside the mainstream was acknowledged and addressed by the then eight-year-old NEA, which decided to begin funding so-called "alternative spaces." Alternative spaces like New York's Artists Space, P.S. 1, and the Clocktower, and the Los Angeles Institute for Contemporary Art began showing a wide range of experimental and/or socially and politically conscious art in conjunction with artists' coop-eratives such as AIR and Soho 20 in New York and N.A.M.E. Gallery in Chicago. There is hardly a political artist working in New York who did not show at an alternative space early in his or her career. These exhibition spaces provided arenas for untried art and also served as fertile ground from which commer-cial galleries, in particular, could cull new talent.

It would not be an exaggeration to see the systematic support for a

multitude of programs and institutions as one of the practices that sparked the conservative attack on the NEA. Not only were unacceptably controversial artists receiving grants, but their work was being shown, and it was potentially influencing the multitudes of Americans who began attending art exhibitions in the 1980s. Because so many of these artists worked outside the commercial art establishment but had a foothold in the alternative establishment, one way to conveniently silence them was to shut down their essential source of sustenance, NEA funding.

Indeed, the battle for funding levels for a wide range of social programs that was fought during the 1980s and into the 1990s was reflected in the arts. One crucial area in which the government unconscionably withheld funding was for AIDS research, health care, education, and support systems, a circumstance that drew the art world into the fight. Private individuals from varied walks of life began organizing research and treatment themselves, at the same time that they were agitating for more government action.

The most vocal and most visible AIDS activists have been members of ACT UP (the AIDS Coalition to Unleash Power), which was founded in New York in March 1987. Within months of its organization, the late William Olander, senior curator at the New Museum of Contemporary Art, offered ACT UP window space for an exhibition piece about AIDS. Douglas Crimp and Adam Rolston described the work:

> An ad hoc committee was formed by artists, designers and others with various skills, and ... Let the Record Show, a powerful installation work,

was produced. Expanding SILENCE =DEATH's analogy of AIDS and Nazi crimes through a photomural of the Nuremberg trials, Let the Record Show indicted a number of individuals for their persecutory, violent, homophobic statements about AIDS ... and, in the case of then president Ronald Reagan, for his six-year-long failure to make any statement at all about the nation's number-one health emergency.[7]

A noteworthy aspect of AIDS activist graphics in terms of political imagery was their visual sophistication and factual thoroughness. But the visuals were not wholly new inventions: the artistic styles and strategies of mainstream artists such as Jenny Holzer, Hans Haacke, and Barbara Kruger were appropriated and recast in the form of posters, placards, stickers, and T-shirts. The ACT UP graphics wing organized itself as Gran Fury and has been further sanctioned by the art world by participation in museum shows and an invitation from Artforum magazine to produce an artist's project for the October 1989 issue.

Like much else under capitalism, overtly political art may be just another phase or fashion destined to extinguish. Dealers and collectors show signs of impatience while they await the emergence of the next new style or movement, which could easily be implicitly political art that supports rather than challenges the status quo. How much the NEA's increasingly conservative policies will undermine the production and exhibition of political art remains to be seen. But given the panorama of social, economic, and political problems facing the United States, both at home and abroad, the political in art will continue to have plenty of fuel.

Carol Squiers is senior editor at American Photo *magazine and writes a regular news column for* Artforum.

NOTES

1. This is not to say that women artists are now fairly represented in the art world; they are not, as the continuing appearance of the Guerrilla Girls' posters indicting the sexism of the art world indicates. Still, it was an undeniable victory that women artists achieved what they did in so little time.
2. The issue of racism in the art world is beginning to be acknowledged. In its September 1990 issue, *Art in America* devoted sixteen pages to an article and interviews by art historian Maurice Berger on the part racism plays in the museum and gallery system.
3. Critic Lucy Lippard has written extensively about these artists; see in particular her *Get the Message? A Decade of Art for Social Change* (New York: E. P. Dutton, 1984).
4. See Rosalyn Deutsche's essay, "Property Values: Hans Haacke, Real Estate, and the Museum," in *Hans Haacke: Unfinished Business* (New York: New Museum of Contemporary Art; Cambridge, Mass.: MIT Press, 1986), for an excellent discussion of these works.
5. Deutsche, "Property Values," p. 25.
6. Quoted in *Hans Haacke: Unfinished Business*, p. 96.
7. Douglas Crimp with Adam Rolston, *AIDS Demographics* (Seattle: Bay Press, 1990), p. 15.

Exhibition Checklist

Unless otherwise noted, the work is in the collection of the Eli Broad Family Foundation.

JOHN AHEARN
BACK TO SCHOOL, 1985–86
consists of five sculptures:
JAY WITH BIKE
oil on fiberglass
52 × 55 × 16
KIDO AND RALPH
oil on fiberglass
80 × 63 × 16
MAGGIE AND CONNIE
oil on reinforced polyadam
68 × 55 × 18
THOMAS
oil on reinforced polyadam
46 × 29 × 7
TITI IN WINDOW
oil on reinforced polyadam
72 × 30 × 12

TOBY AND RAY, 1989
oil on fiberglass
47 × 43 × 39

JEAN-MICHEL BASQUIAT
BEEF RIBS LONGHORN, 1982
acrylic and mixed media on canvas
60 × 60
The Eli and Edythe L. Broad Collection

EYES AND EGGS, 1983
acrylic and collage on cotton drop cloth
119 × 97
The Eli and Edythe L. Broad Collection

JONATHAN BOROFSKY
MALE AGGRESSION NOW PLAY-
ING EVERYWHERE AT 2,968,937,
1986
acrylic on canvas
130 × 144

SUE COE
THE CHILDREN ARE GOING
INSANE, 1983
graphite and collage on paper mounted
on canvas
73 ¹/₂ × 69 ¹/₂

WELCOME TO R.A.F. GREENHAM
COMMON, 1984
mixed media and collage on paper
50 × 73 ¹/₂

LEON GOLUB
MERCENARIES I, 1976
acrylic on canvas
116 × 186 ¹/₂

MERCENARIES III, 1980
acrylic on canvas
120 × 198

WHITE SQUAD V, 1984
acrylic on canvas
120 × 161

HANS HAACKE
OELGEMAELDE, HOMMAGE
A MARCEL BROODTHAERS
(Oil Painting, Homage to Marcel
Broodthaers), 1982–83
installation; oil painting in gold
frame, picture lamp, brass
plaque, brass stanchions with
red velvet rope, red carpet,
and photo mural; overall
dimensions determined by exhi-
bition space; painting: 35 ¹/₂ ×
29 including frame; carpet: 35"
wide, length variable; brass
plaque: 4 ¹/₂ × 12 ; photo
mural: dimensions variable

KEITH HARING
UNTITLED, 1983
vinyl paint on vinyl tarp
180 × 276

UNTITLED, 1984
acrylic on canvas
120 × 180

JENNY HOLZER
UNDER A ROCK, 1986
installation of thirteen works; three elec-
tronic LED signs and ten granite benches

ANSELM KIEFER
DEUTSCHLANDS GEISTESHELDEN
(Germany's Spiritual Heroes), 1973
oil and charcoal on burlap mounted on
canvas
121 × 268 ¹/₂

BARBARA KRUGER
ROY TOY, 1986
color photograph
138 ¹/₂ × 90 ¹/₂

UNTITLED (YOUR BODY IS A
BATTLEGROUND), 1989
photographic silkscreen on vinyl
112 × 112

ROBERT LONGO
UNTITLED (White Riot Series), 1982
charcoal, graphite, and ink on paper
96 × 120
The Eli and Edythe L. Broad Collection

ROBERT MORRIS
UNTITLED, 1987
silkscreen, encaustic on aluminum panels,
and painted cast fiberglass
102 × 124 × 14

TOM OTTERNESS
MASS WORKERS, 1983
painted cast polyadam
141 × 45 × 6

CINDY SHERMAN
UNTITLED FILM STILL, 1978
black and white photograph,
edition 5/10
10 × 8
The Eli and Edythe L. Broad Collection

UNTITLED FILM STILL, 1978
black and white photograph,
edition 8/10
10 × 8
The Eli and Edythe L. Broad Collection

UNTITLED, 1981
color photograph, edition 10/10
24 × 48
The Eli and Edythe L. Broad Collection

UNTITLED, 1982
color photograph, edition 1/10
45 ¹/₄ × 30
The Eli and Edythe L. Broad Collection

UNTITLED, 1989
color photograph, edition 2/6
92 ⁷/₈ × 35 ⁷/₈

UNTITLED, 1989
color photograph, edition 3/6
53 ¹/₂ × 40 ¹/₂

ANDY WARHOL
MAO-TSE-TUNG, 1973
acrylic and silkscreen on canvas
26 × 22
The Eli and Edythe L. Broad Collection

DAVID WOJNAROWICZ
THE NEWSPAPER AS NATIONAL
VOODOO: A BRIEF HISTORY OF
THE U.S.A., 1986
oil on wood
67 ¹/₂ × 79 ¹/₂

BOARD OF TRUSTEES

OFFICERS

JAMES R. COMPTON, President

JAMES E. VENY, Vice President

CAROLE MINTON, Secretary

BRYAN C. POLSTER, Treasurer

TRUSTEES

WAYLAND M. BRILL

JAMES R. COMPTON

JACK W. CONNER

DERREL B. DE PASSE

R. THOMAS FAIR

TOBY FERNALD

JANICE W. FOX

PAUL FREIMAN

DREW GIBSON

FRANCIS J. HARVEY

JOE HEAD

R. FREDERICK HODDER

DONALD F. IMWALLE

ANN HARRIS JONES

MARLIN KREBS

PHILIP MASTROCOLA

JOE McCARTHY

CAROLE MINTON

ANN MARIE MIX

DAVID O'MARA

GERALD POLK

BRYAN C. POLSTER

MARK H. RITCHIE

KENNETH A. RODRIGUES

EDWARD SCHULTZ

KIMBALL SMALL

JAMES E. VENY

DOROTHY WALWORTH

GORDON YAMATE

STAFF

MONICA ATTANASIO, Museum Store Assistant*

SUNNY BERTSCH, Assistant Director, Museum School

JOSI CALLAN, Associate Director, External Affairs

MADELYN CRAWFORD, Curator of Education

I. MICHAEL DANOFF, Director

JEFFREY FLINT, Lead Security Guard*

DIANNE HOOVER, Curatorial Assistant

KATIE HOVIG, Maintenance Technician*

CAROL JACOBSEN, Administrative Assistant to the Director

RICHARD KARSON, Preparator

JENNIFER KRESCH, Membership Manager

LEE KUCERA, Grant Writer*

DAVID BRENT LARIMORE, Security Guard*

LINDA LARKIN, Public Relations Secretary

DIANE LEVINSON, Museum School Director

BYRON MCCRANEY, Security Guard

CHRISTINA MILLER, Museum Store Manager

DEBORAH NORBERG, Registrar/Associate Permanent Collection Curator

MADELON PALMA, Museum Store Assistant*

FABIAN PANTOJA, Assistant Chief of Security

JAMES PANTOJA, Chief Security Guard

STEPHANIE PARKHURST, Receptionist*

JACKI PICKETT, Business Manager

EVELYN ROBINSON, Development Secretary

MARY ROBSON, Curatorial Staff Assistant*

ROMAN SANCHEZ, Security Guard*

ROBIN SMITH, Associate Director of Development

URSULA SURGALSKI, Assistant Director of Public Relations

CHRISTINA TOURS, Bookkeeper

COLLEEN VOJVODICH, Curator

*Part-time staff